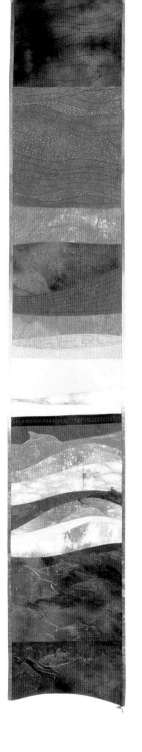

Landscape in Contemporary Quilts

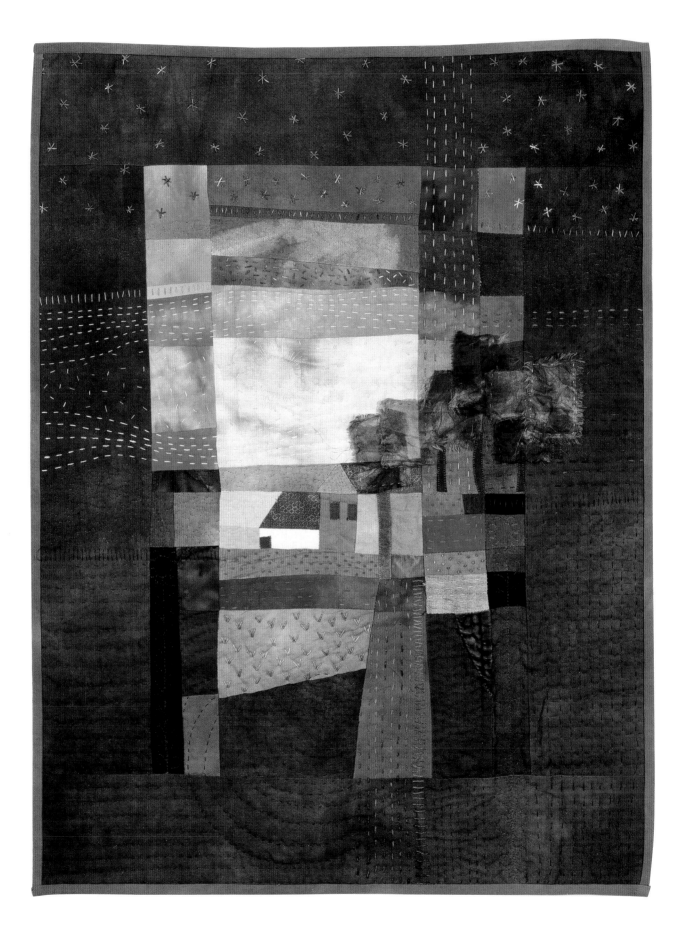

Landscape in Contemporary Quilts

Ineke Berlyn

BATSFORD

Page 1: **Long Indigo Seascape**. *See caption on page 58.*

Page 2: **Dutch Landscape**. *My first interpretation of a Ton Schulten painting (see page 20), in dyed calico with hand and machine quilting.*

Below: **Armadillo**. *See caption on page 60.*

Opposite page: **Antigua**. *See caption on page 80.*

First published in the United Kingdom in 2006 by
Batsford
151 Freston Road
London
W10 6TH

An imprint of Anova Books Company Ltd

ISBN 0 7134 8974 X
ISBN (13-digit) 9780 7134 8974 3
A CIP catalogue record for this book is available from the British Library.

10 9 8 7 6 5 4 3 2

Reproduction by Anorax Imaging, Leeds, UK
Printed and bound by C T Printing Ltd, China

This book can be ordered direct from the publisher at the website:
www.anovabooks.com
Or try your local bookshop

Distributed in the United States and Canada by Sterling Publishing Co., 387 Park Avenue South, New York, NY 10016, USA.

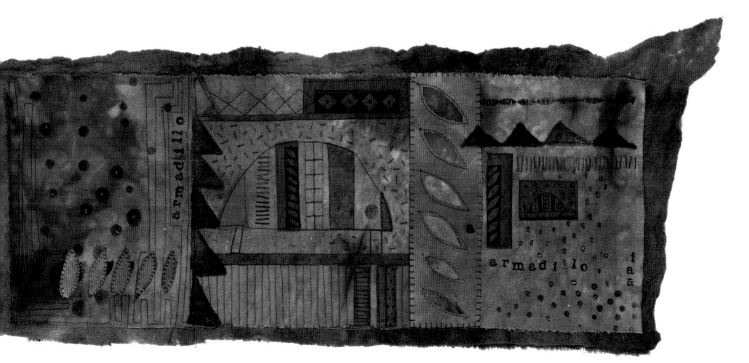

Contents

Who is this book for?

I would like this book to be enjoyed by quiltmakers, patchworkers, and textile artists of all abilities, but I also like to think that even non-stitchers might be captivated by the colour and the landscapes portrayed. With its step-by-step instructions, *Landscape in Contemporary Quilts* enables novice quilters to produce delightful textile wallhangings representing their favourite landscapes.

Landscape is a broad starting point, and in this book we travel through the many possibilities that a simple landscape photograph can inspire. Through clear and simple instructions, beginners can transform their own ideas into unique pieces of art. Each chapter is illustrated by colourful visuals taken from my own work and from the work of the many outstanding artists who have found inspiration in a beautiful view.

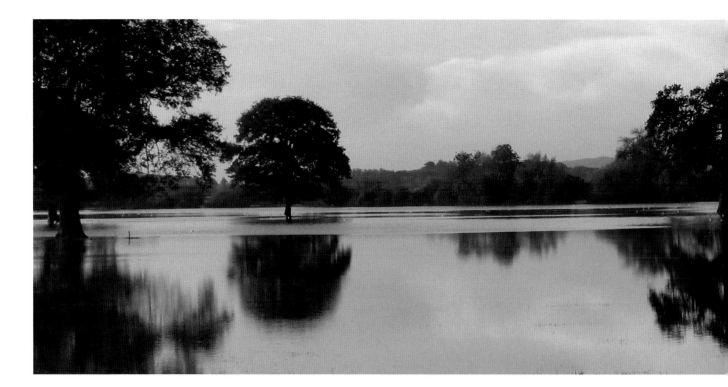

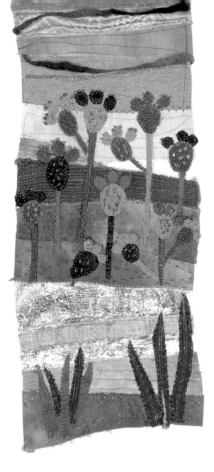

Introduction

landscape n. [Dutch *landschap* (land, area)] 1. an extensive area of scenery as viewed from a single place. 2. a painting, drawing, or photograph depicting natural scenery. ~vb. 3. to improve the natural features of an area of land.

contemporary adj. 1. living or occurring in the same period. 2. existing or occurring at the present time. 3. modern in style or fashion 4. of approximately the same age as another.

quilting ~vb. to stitch together two pieces of fabric with padding between them.

Above: **Cactus** *(Heather Stratton). The cacti are stuck on with Bondaweb (Wonder Under) and the piece is quilted by machine and hand. 23 x 53cm (9 x 21in).*
Below: Trees reflected in the Severn flood plain, Worcestershire, UK.

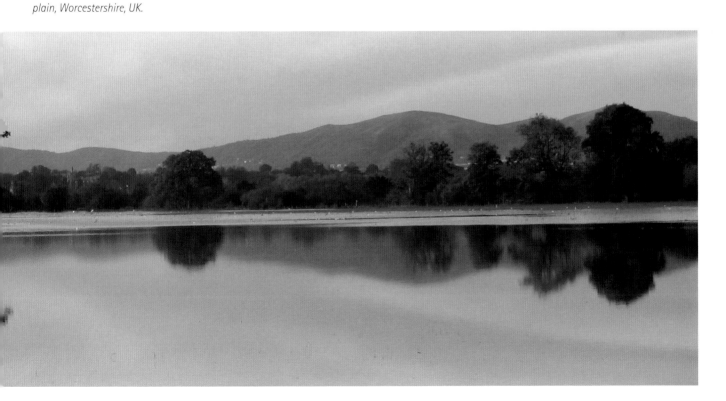

As I looked up the word 'landscape' in a couple of dictionaries (the above definitions are composites taken from the Cassell's and Collins English dictionaries), I was quite surprised to find that it has a Dutch origin, which gives me a good natural starting point – being of Dutch origin myself.

Quilting is and has been my passion ever since I found a City and Guilds course in patchwork and quilting, and the style in which I like to interpret the landscape in my work is definitely contemporary. Once I had learnt the rules, it became fascinating to see what happened when I broke them and pushed out the boundaries a bit further.

It was pure chance that got me involved in putting together this book. In my role as regional co-ordinator for the Quilters Guild I had invited Sandra Meech to speak at one of our area meetings, and while admiring her beautiful book *Contemporary Quilts: Design, Surface and Stitch* (Batsford, 2003) I mentioned my idea for a book on landscapes. She encouraged me to put a proposal together, which was accepted, and I spent a wonderful year researching and working on several landscape projects in fabric and stitch.

An amazing view has always been a great source of inspiration to all kinds of artists throughout the centuries. Wordsworth waxed lyrical as he

> *wandered lonely as a cloud*
> *That floats on high o'er vales and hills,*
> *When all at once I saw a crowd,*
> *A host of golden daffodils;*
> *Beside the lake, beneath the trees,*
> *Fluttering and dancing in the breeze ...*

Van Gogh's vibrant French landscapes show daring use of brilliant colour, while the contemporary installations of the sculptor Andy Goldsworthy transcribe landscape art into yet another dimension.

Looking at all these diverse forms of landscape art and combining them with landscapes one admires will give a wealth of inspiration to any quilt maker or textile artist.

I love working with colour, and although playing with crayons and paints is a good starting point, my passion is to be able to translate this into textiles.

This book consists of a journey exploring colour, texture, layers and stitch. The search to find astonishing colour combinations in the landscape throughout the seasons was absorbing, and more often than not I would find the perfect photo opportunity right on my doorstep in Worcestershire, or my other doorstep in the Vendée region of France.

Above: A stunning view of the rolling mountains and vineyards of Franschoek, South Africa.

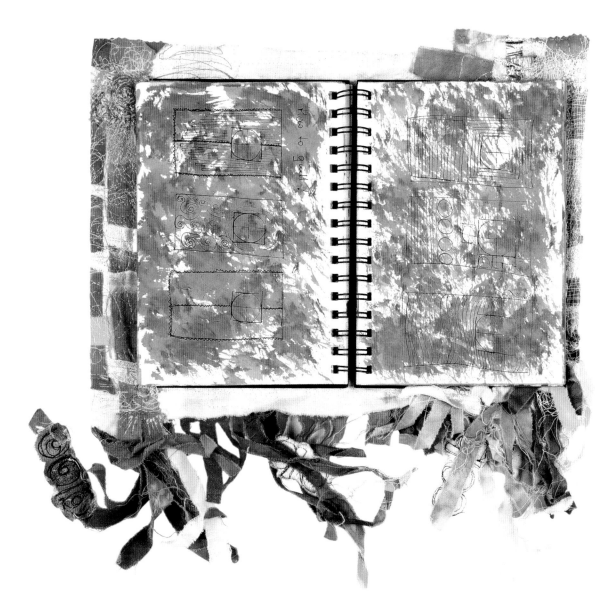

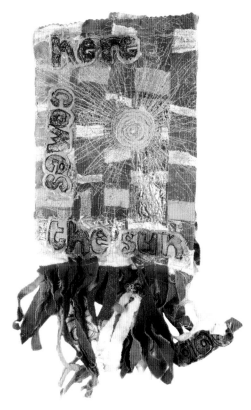

Above and right: **Here Comes the Sun sketchbook**. *This sketchbook contains the research and development that led to* Enlightenment *(page 45) and* Here Comes the Sun *(page 55).*

Travelling through this book, you will visit the various stages of the design and construction of a landscape quilt. Along the way you are encouraged to keep a journal or sketchbook in which to collect all kinds of words, thoughts, sketches, postcards, photographs and experiments.

Putting colour on paper or fabric is like performing a magic show. Pouring dye on fabric and seeing the colours flow and merge, waiting for the chemicals to do their job, rinsing and ironing are all parts of the great act of dyeing different fibres and can all be enjoyable.

Then there is the fun of cutting and piecing them together – again a different play with colour – and finally stitching into the finished work to add that beautiful tactile quilted texture.

All the ideas in this book can easily be carried out at home. Each project gives a simple starting point that can be copied and subsequently inspire more individual experiments. Just let your creativity run free, work with what you love, use your instinct and keep your mind open to whatever idea may come your way.

Always remember: you are doing this for fun!

Right: The Malvern hills reflected in the floodwaters of the River Severn, Worcestershire, England.

Below: This beach hut balances on the rocks at Les Rochers, Vendée, France.

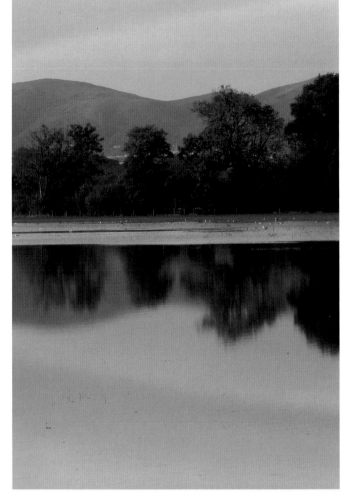

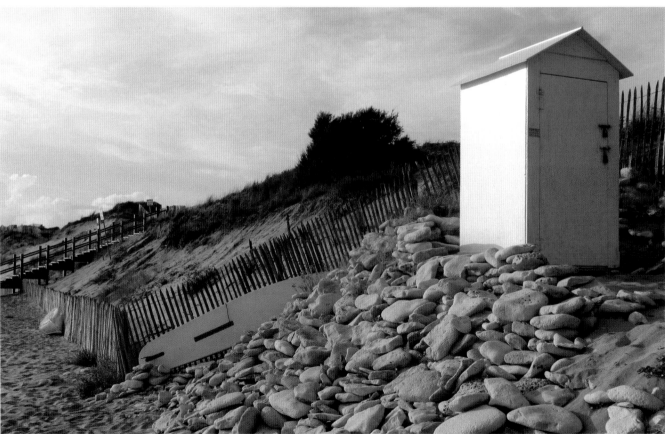

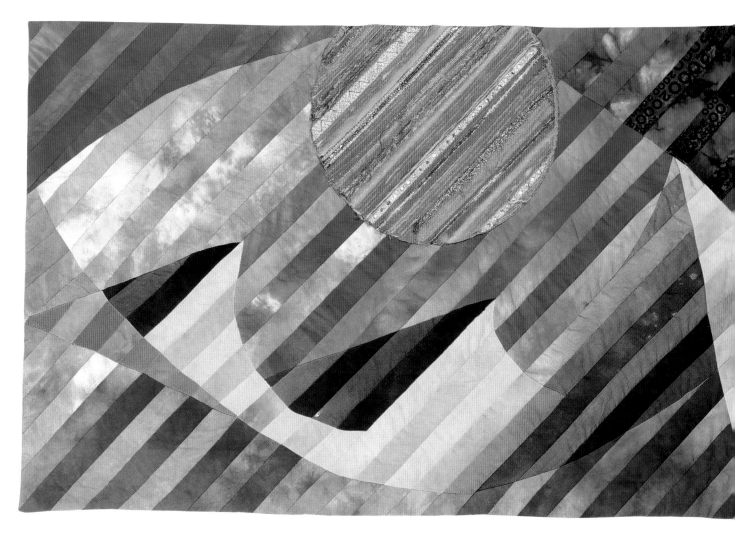

Above: **Pyramids**. *A diagonal strip-quilted wall hanging inspired by the work of the American quilter Michael James. 76 x 50cm (30 x 20in).*

Threads of Inspiration

A stunning view makes a fantastic starting point. How often have you looked in amazement at an ultramarine sky disappearing into an azure blue sea, a brilliant fiery sunset, or a carpet of bluebells in a forest of fresh spring greens and thought, 'I wish I could create something from that with my fabrics?' Well, you're not alone. Landscape and textiles are a perfect combination – you only need to think of the fact that the word 'patchwork' is so often used when describing a rural vista of multi-coloured fields.

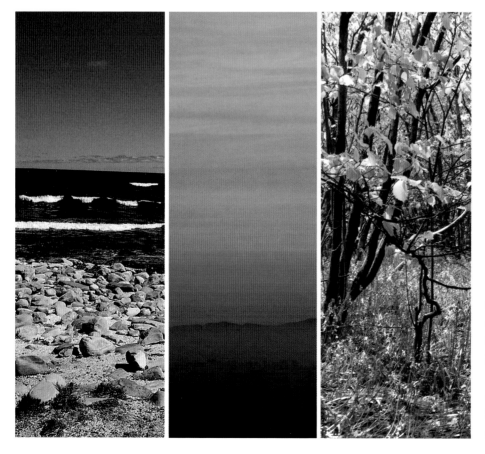

Far left: The Cape of Good Hope, South Africa. Middle: Sunset over Worcestershire, UK. Left: Bluebell woods at Lickey Hills, West Midlands, UK.

Right: **Bluebells.** *Fabric shapes bonded between layers of sheers and tulle, then machine-quilted. 20 x 27cm (8 x 10in).*

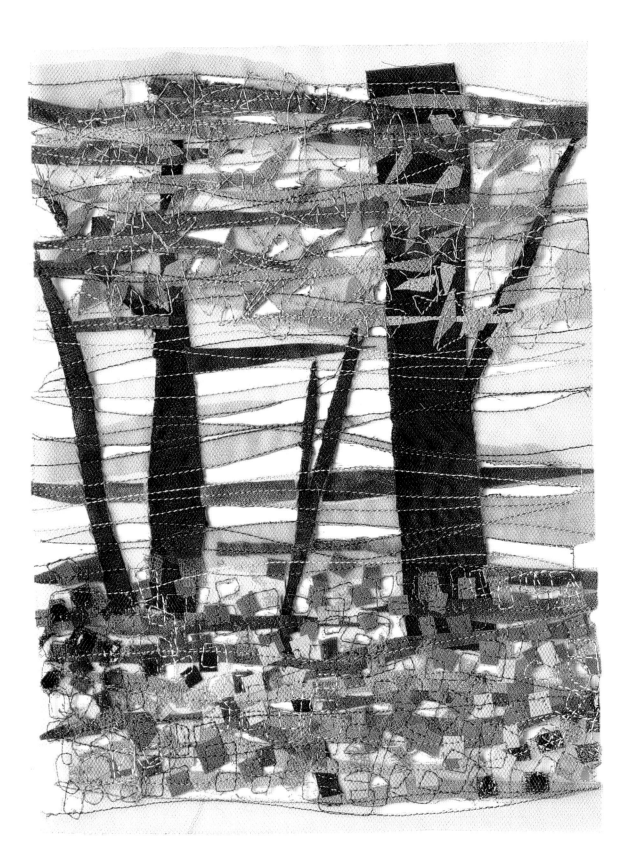

Throughout the centuries artists have been inspired by breathtaking land- or seascapes, and have transformed these into priceless pieces of art. In the past, painters like Constable, Turner and van Gogh would travel the countryside, armed with only a simple sketchbook and pencil to put their first impressions down on paper before working them up on canvas in their studios.

Transferring a landscape onto canvas has been popular since the early 18th century, and in those early days there was a prescribed formula for painting a rural scene. The 'ideal' landscape picture would consist of trees outlined against a sunset, some water – usually a river or pond – in the centre, and, further in the distance, perhaps a castle on top of a hill forming the background. Since then landscape art has continued to evolve. In the late 19th century Paul Cézanne became the first of many to represent the landscape in an almost cubist style, which in the early 20th century gave rise to the more abstract landscapes of Wassily Kandinsky and Paul Klee. These artist did not see themselves as representing the world, but rather as reporting and recording within it.

Landscapes Urban and Rural

In contrast to the rural landscape, there is also the urban landscape to consider; it can be just as inspiring because it is the place where most of us live and work. It too is full of shapes, the more pronounced verticals of buildings contrasting with the horizontal lines of rectangular windows. Reflections are everywhere in the big plate-glass windows of shops and offices, and if you compare these with the reflections you find in the rural environment the comparisons can be quite interesting. Both Paul Klee and Ton Schulten (see page 20) have been stimulated by the city and its angular shapes, and have created brightly coloured blocks within blocks, which are very suitable for the patchworker to translate. Alicia Merrett used very bright hand-dyed fabrics to create the fabulous urban landscape quilt shown on the opposite page.

Inspiration can come from a wide range of sources, and when looking at your own favourite landscape – whether it is the view you see every day or a painting you really like – you will find that over a period of time the same ideas and interests will keep reappearing and can sometimes become almost an obsession. My own personal favourites are tulips, dolphins, the sun and Buddhism.

We all have colours that we like working with, and the same goes for the choice of subject: the sea, hills, trees or your own garden. It is good – I would even say essential – to keep attending regular or one-off workshops by textile artists teaching innovative techniques or development sessions. Working in a class with other students will encourage discussions, promoting development in different directions, and by learning and experimenting with new techniques your design will flourish and evolve. Images change with the passage of time and often your own ideas expand along the way. Quilts are not just blankets you put on a bed to keep warm, but will be very much a reflection of the way you live. Your most important aim is to create something you will love!

Three words are key for your personal artistic development:

Intuition – go with your instinctive choice. More often than not the piece of fabric you spontaneously picked up first will turn out to be the best – so don't waste too much time pondering all the options.

Above: **Mini landscape on linen.** *Small landscape painted on French linen with acrylic paint and pearlescent and gold medium.*

Above: Detail from a sketchbook made in Venice.

Below: Mojacar Evening *(Alicia Merrett) Hand-dyed cotton sateens, freehand cut and stitched, machine quilted. Alicia found inspiration in the Moorish hill village of Mojacar in southern Spain, where the sky turns purple in the evenings and the white houses are illuminated by marvellous coloured light beams.*

Learning – continue with classes and learn from others. Attending a regular weekly or monthly class will give you an opportunity to concentrate without being interrupted by a telephone or a load of washing that needs hanging out. It will give you the chance to have that all-important interaction with, and advice from, the tutor – and also from the other students around you.

Awareness – always keep an open mind and a sketchbook about you, so you can record impressions of landscapes you might come across.

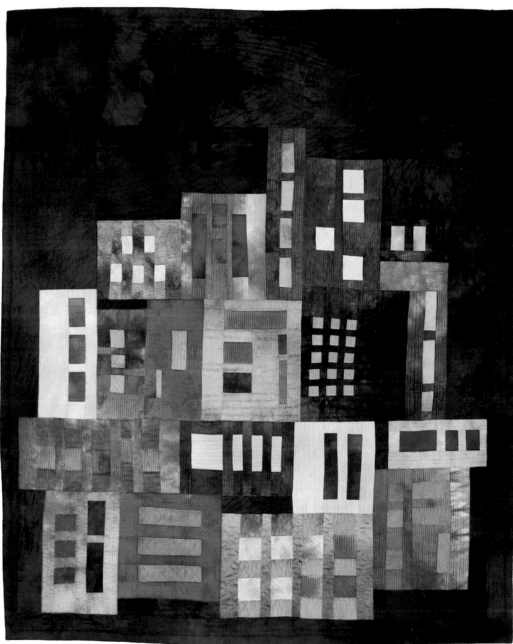

The Netherlands

Starting from my first City and Guilds class, when I chose the tulip as a quilt design, I have often gone back to my roots in the Netherlands to find that all-important inspiration. It is the obvious place to start looking, to go back to where you grew up – keep it close to home, and reflect on the landscape immediately around you. If you look around your home you will more than likely find landscapes in the pictures on the walls, in postcards you received and in the background of family photographs.

I was born and grew up in the Netherlands surrounded by the colourful textiles of my parents' furniture shop. My grandmother knitted, and always had busy hands – it was considered quite sinful to do nothing, except on Sundays! With my mother's help I learned to sew, knit, crochet and embroider. She herself was always sewing, either making curtains for the business or making our clothes, so anything to do with a needle seemed to come almost naturally, although an in-born aptitude helps. You either love it or you don't. My younger sister is very arty and very good with colour, but she has never possessed the same passion to stitch. My youngest brother, however, continued the family tradition and successfully designed a range of contemporary furniture. My own strong sense of colour, together with a love of landscapes and sunshine, has always been there.

Holland is an easy source of inspiration, with its rich history of culture, colour and pattern. When flying into Schiphol Airport at Amsterdam during April or May the view from the air of the tulips arranged in a brightly coloured patchwork of rectangular fields is an inspiration to any person – especially the textile-oriented one. Seeing the flowers from the ground in the beautiful parklands of the Keukenhof is also spectacular.

Above: **Tulip design.** *My very first impulsive choice for a traditional quilt design was the tulip, a quintessential Dutch motif.*

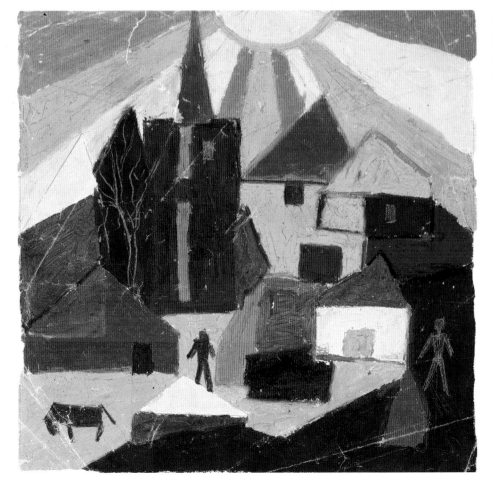

Left: All the aspects of landscape that now fascinate me are found in this picture, which I drew when I was about 10 years old: the sun, the bright colours and the style of abstract cubism.

Opposite page: **Amsterdam.** *Delicate sheers and muslin cottons in the shapes of the gabled houses that line the canals of Amsterdam are all layered on top of one another to make up this piece. Hand stitched with space-dyed cotton thread. 33 x 36cm (13 x 14in).*

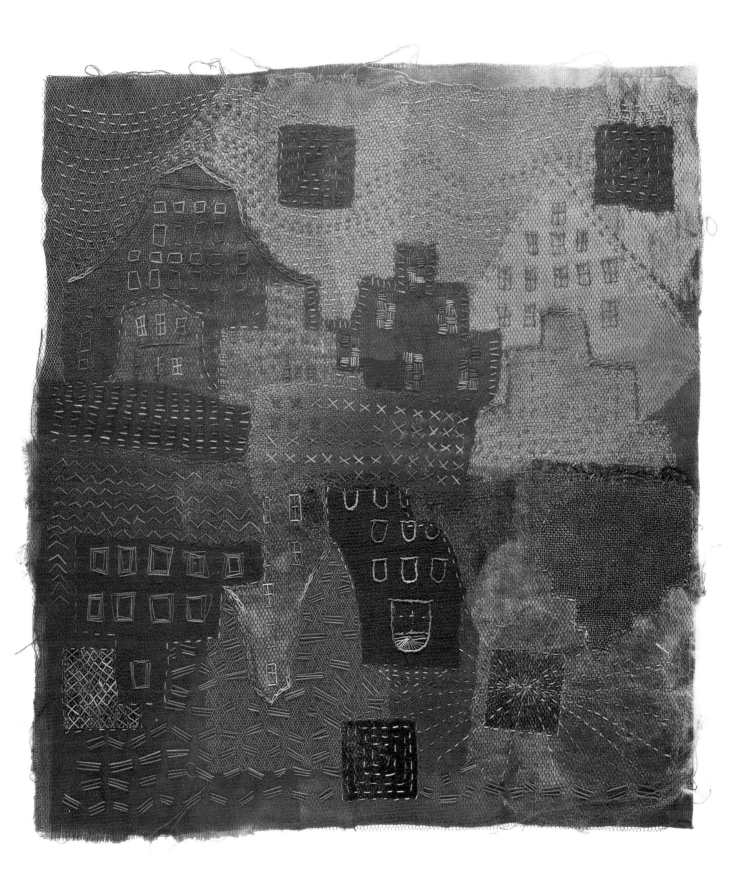

Then there is the ancient history and multitude of patterns of the crisp blue-and-white hand-painted Delft porcelain, and of course the work of the world-famous Dutch artists through the centuries, from Rembrandt and Vermeer to van Gogh and Mondrian, who expressed their visions of landscape in oils on canvas. Finally, there is the variety and colour of textiles in all the different variations of national costume that are still worn today. Each village in the Netherlands has its own fashion and particular sets of colours that are used as signs of celebration or mourning. For me as a quilter, the inspiration is never-ending.

Above: **Large Holland book.** *Project book on the colours and costumes of Holland. Made for my City and Guilds Patchwork and Quilting diploma.*

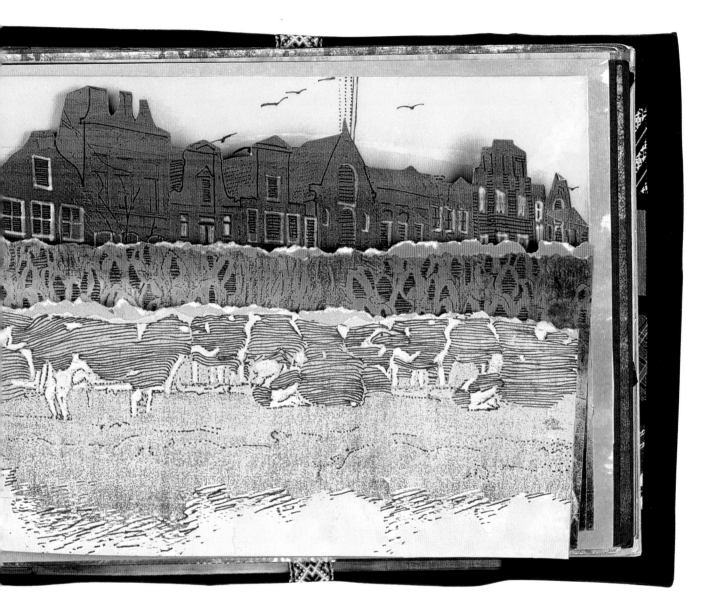

Above: Omaha Beach, Normandy, France, on a summer day.

Ton Schulten

While working towards the final piece of my City and Guilds examination a good friend in Holland introduced me to the work of the Dutch contemporary artist Ton Schulten, and everything just seemed to fall into place. His work is so bright and imaginative, and just begs to be transformed into fabric – a true patchworker's dream. A trip to Holland is not complete for me without a visit to the pretty artists' village of Ootmarsum in the middle part of the Netherlands, nestling on the eastern border close to Germany, where the Ton Schulten galleries are slowly taking over one of the gallery-lined cobbled streets. Ton's wife Anke runs the extremely welcoming 'Chez Moi' galleries. If you're lucky the man himself might put in an appearance, and he is always quite happy to stop and chat to a customer or fellow artist. Travel might not always be convenient but you can visit his virtual gallery at www.tonschulten.nl, or you can buy his calendars or diaries at some of the larger bookstores in the UK.

Initially I experimented by interpreting pictures from the calendar. This helped me to understand the way the artist worked with colour, particularly brightness and shade, and bit by bit I learned how to approach the construction of a similar picture in textiles.

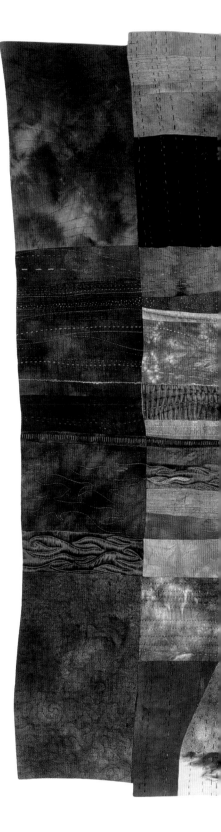

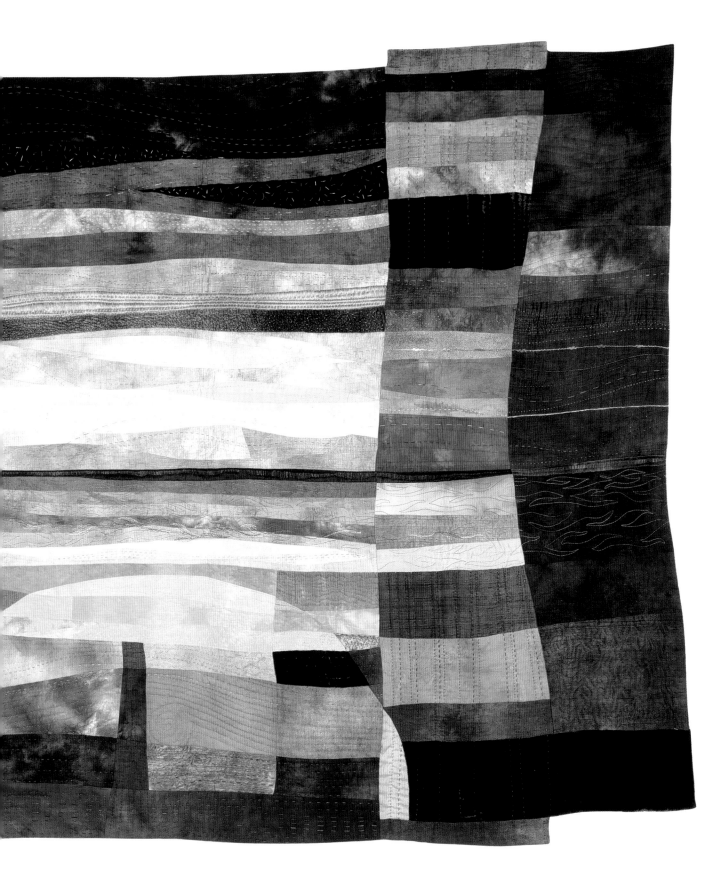

Above: **Omaha**. *The photograph looking out on Omaha Beach, France (opposite page), inspired this quilt. A collection of vintage linens, silks, satins, velvets and cottons were hand-dyed and machine-pieced in free-flowing lines, and quilted by hand and machine with a range of commercial and dyed threads. On the reverse, white crosses have been bleached out as a reminder of what lies behind when you admire this view. 135 x 165cm (53 x 65in).*

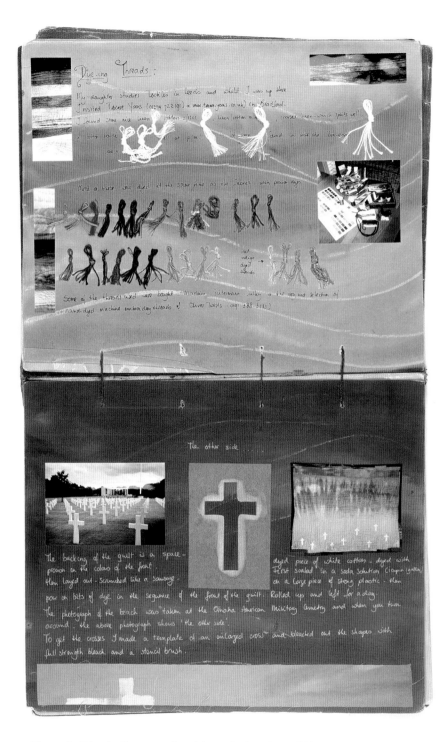

Left: **Omaha workbook**. *This book contains the design steps that were taken to create the* **Omaha** *quilt (page 21). The lower page shows the reverse side of the quilt – reflecting on what is behind you when you are taking in the view.*

After a holiday in France and a visit to the beaches of Normandy, among my photographs was a particularly vibrant picture taken at Omaha Beach (see page 20). All the colours seemed to interact with each other – a clever trick often played by nature – the greens of the shrubbery in the dunes contrasting with the warm orange sands of the beach, which in turn melt into the deep blue horizon of the sea, finally erupting in this soft pastel sky with hints of pink and lilac. I set myself the challenge of seeing if I could translate this photograph into a contemporary landscape quilt based on the style of Ton Schulten's paintings.

I first made a small A3-size (297 x 420mm/11⅝ x 16in) version of the work, dyeing the fabrics and using all kinds of different textures from vintage linen (found at an antique market) to luxurious silk and viscose velvet. The final version of *Omaha* was very successful, and the start of a colourful journey through landscape quilts and beyond.

Art Begins at Home

Throughout the chapters of this book I would like to guide you step by step in transforming your favourite picture into a contemporary landscape quilt. I am not a very good 'fine artist', but I love putting colour on paper or fabric and taking photographs, and that makes for a perfect starting point, mainly because the enjoyment and passion are there. Recording your first impressions in pictures and words is very important.

These days we are very fortunate with instant recording techniques such as digital cameras, which enable us to take these views home and start experimenting straight away. Computer manipulation of images can give incredible results, but not everybody is able or happy to work in this way.

First we have to go back to the basics by taking a look at our own landscape. Take a walk close to home with your camera, sketchbook, pen and maybe a small pocket set of watercolours, and see what colours nature throws at you! As painters do, take those important first impressions of the view home and work on them further in the studio. The most important aspect of your choice is that it really interests you. That way, you will love working with it over and over again, just like the good view you enjoy day after day.

Try to look at things with a fresh pair of eyes; look at colour and shape before looking at the whole picture – you will be amazed at what you see!

Right: Sketchbook pages exploring colour and composition.

Take a walk in the country one day. Look at the lines of the hills in the distance and the tops of trees bordering a field, and how they flatten out further away. Clouds also make fascinating shapes. Patterns will form, colour will develop, and ideas start to build in your head.

Then take the same walk at a different time of day and see what the light does to your landscape. Shadows will form different patterns and colour will have changed completely. Try painting your landscape with just one colour, concentrating on the different tones. Go back again at a different time of year and take note of what effect the change of season has on the place. Recording all these changes will make an interesting, ongoing and very useful exercise.

There are many different ways in which a landscape can inspire you as an individual. It is a limitless source of inspiration, full of richness and variety. It is up to you to approach each project with a clear and open mind. If you treat each view – even the familiar ones – as new and unknown, your work will stay fresh. Through these exercises and observations you will learn to see a different landscape each time you look. When you next visit your local art gallery, you can also ask yourself questions about the paintings: 'How did the artist do that?' 'Why do I like it?' 'What do I see?' Make notes and look for answers.

Below: **Malvern sketchbook.** *Sketchbooks with several paintings and sketches in preparation for three sheer Malvern pieces.*

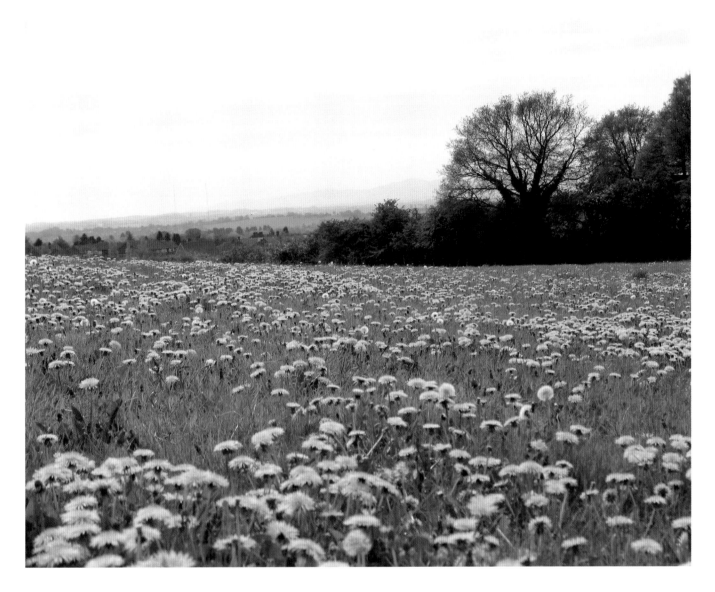

Above: This is the field where I walk my dog most days and I find it gives me plenty of inspiration, especially when it is filled with dandelions in the spring.

When I walk my dog up the hill near my house, my reward at the top is the panoramic view in front of me that takes in the wide sweep of the whole Worcestershire countryside, framed in the distance by the Malvern Hills. The scene changes every day with the seasons, the weather and even the time of day. When the sun shines, the fields and the valley below form a patchwork of bright colours but the distant hills are thrown into shadow. This continual play of light and shade gives interest to a landscape, and will be essential to your design.

Ton Schulten works with very strong contrasts and exaggerates the brightness and intensity of the colours he sees or perceives. If you sit in a field in the summer the colours you see might be lime green, fluorescent yellow and hot orange, with dark navy rows of trees. A yellow field of corn next to a bright field of fluorescent orange barley becomes the focal point of your picture, and at the same time sets the tone of colour to be used around it. Alternatively, on a bright icy day in winter a landscape might sparkle with silver, whites and blues, with shadows appearing a deep navy, trees standing tall in dark blue-purples, and the odd bright-red roof livening up the image. All these factors will help you create a bright picture-postcard centre in your quilt, offset against shades getting darker towards the borders.

Composition

With a panoramic view, too much detail should be avoided: you don't need to include everything you see. Select a few main features – a group of trees, a lake or the impression of a building will add the necessary hint of interest. Patterns in the fields can be added by piecing strips of graded colour or adding creative stitches afterwards.

Using strong horizontal lines gives the impression of space receding away from the viewer. A picture with no apparent horizontal division can look messy; adding a horizon can give your design the visual interest it needs.

Placing the horizon below or above the centre of your design will make your scene more interesting than dividing the space into equal parts. By lowering the horizon you are suggesting a big sky, and this will create a sense of space or infinity. Placing the horizon above the middle will give it more depth, as the eye will travel into the distance – but adding even the tiniest bit of sky will give the composition a spark of freedom. Most landscapes have some of each.

Your landscape work is therefore divided into two sections that meet in the middle:

<div align="center">

Close sky
Middle sky
Back sky

</div>

-------------------------------------Horizon---

<div align="center">

Background
Middleground
Foreground

</div>

Opposite page **Achiltibuie, Scotland**
(Judith Hill). Merino wools layered, felted and embellished with handstitching. 33 x 46cm (13 x 18in).

Below: A rocky beach in South Africa. This picture shows a perfect example of the meeting of sky and land or sea at the horizon.

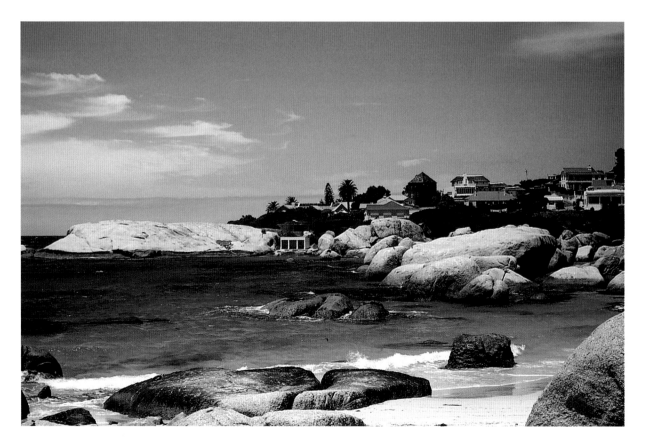

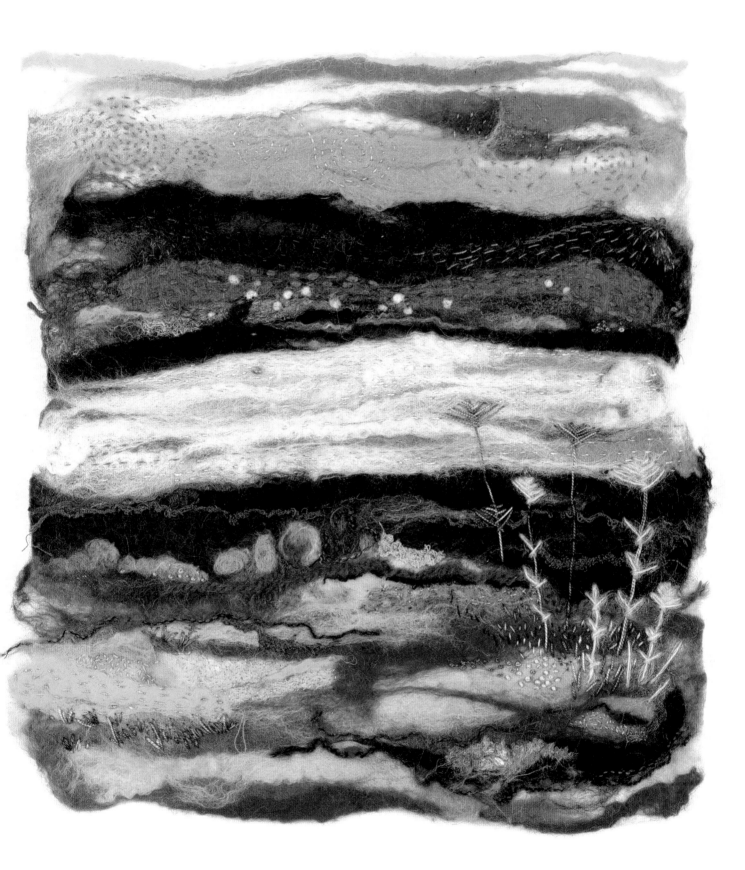

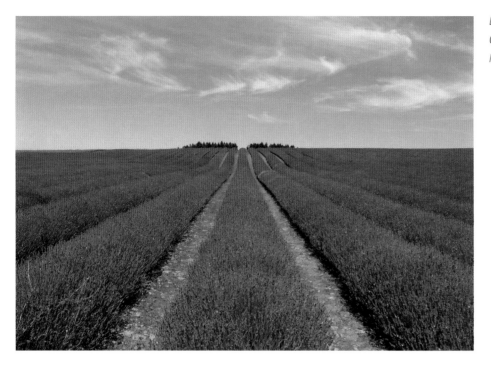

Left: Lavender fields in Snowshill,
Gloucestershire, UK, showing perspective
lines disappearing into the distance.

Adding a few thin lines in the background towards the horizon increases the feeling of
distance, as in the photograph above. When adding a mountain or two, the eye gets taken
even further into the distance.

Giving your picture a bigger sky will create space, and adding a few perspective lines
suggests distance and provides a path for the eye to travel.

Furrows in a ploughed field or neat rows of plants disappearing into the distance give
a picture perspective and an illusion of real distance.

Adding a house or a tree gives the design a focal point, but where exactly you place it
is also an important question. If you look at the drawings on the right, showing possible
places to put a house, you almost instinctively know that the first one (a) does not look
right at all – it is much better to move your house inside the frame (b), or leave some of it
outside the frame (c); your eye will work out what is missing. Another way of helping to
guide the eye through your picture is by adding a path leading to a distant farmhouse.

A different way of interpreting landscapes is by looking at the contours. The lines the
hills make in the distance (d), the tops of the trees (e) or the path taken by a river will
give you beautiful flowing lines that can be used in your design or quilting pattern.

a

b

d

e

c

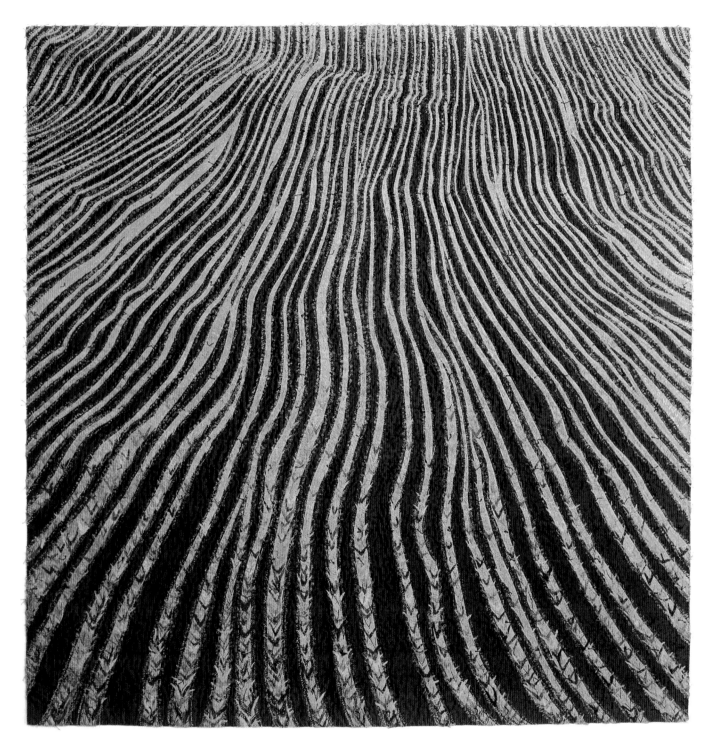

Above: Elizabeth Brimelow is a perfect example of a quiltmaker who is inspired by her immediate surroundings: the meadow that adjoins her garden is the one she has looked out on for twenty years. She has photographed, drawn, picked flowers and walked her dog there. Her quilt Winter Wheat *shows her distinctive mark-making and creative use of perspective lines.*

Travel

These days holidays often take us further afield than ever before, reaching more exotic, interesting and unusual places and cultures. Combined with the leisurely pace of a holiday, this will give you an ideal opportunity to sit, sketch and give colour to all those unique impressions. I often take a small sketchbook with me on holiday, and paint long narrow strips of the colours I see. Doing it again at the end of the day, you will notice how the colours have changed.

Travel may not always be possible or convenient; in that case, have a look at the Sunday newspaper colour supplements, a beautiful calendar or a travel magazine – or visit the local car-boot sale and pick up a few old copies of *National Geographic*. Even if somebody else has done the footwork and clever photography, if a particular picture inspires you, work with it!

A few words are important too, as notes to help you translate your responses to what you see, feel and smell. Map your picture in your mind by writing ten words about your dominant impressions of the scene. Try to keep your responses spontaneous by limiting yourself to about 5 minutes. Maybe an appropriate poem or piece of text (by you or someone else) will also help to focus your thoughts. Painters were not alone in being inspired by the landscape; poets too found inspiration in nature, as Housman did in the 'blue remembered hills' of Shropshire, while Wordsworth walked in his native Lake District, by the Rhine, through the Alps, and as far as the Italian lakes. Words incorporated directly into textiles give them yet another dimension.

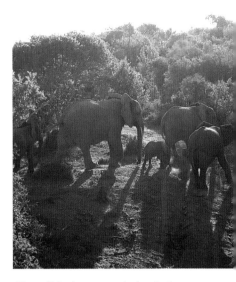

Above: This picture was the inspiration for the **Ellies at Kwandwe** *quilt (shown opposite).*

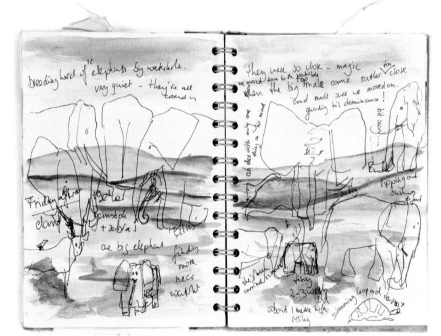

Above: **South African travel journal**. *During the trip I kept a sketchbook diary, filling pages each day with quick watercolour washes and on-the-spot sketches of encounters with elephants, lions and other safari wildlife.*

Right: **Ellies at Kwandwe**. *Soft cotton muslin was distressed with free-machine stitching. Ripped strips of thin fusible Vilene (Pellon) were ironed on then placed on a calico backing and painted with several coats of watercolour. 32 x 38cm (12½ x 15in)*

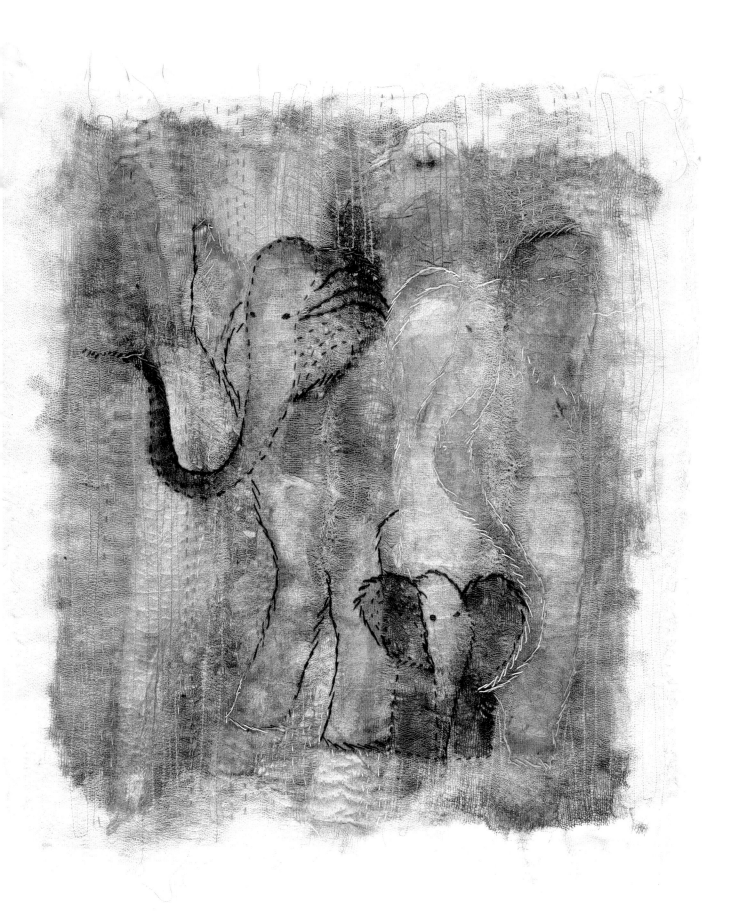

Water

Although I live right in the middle of England – as far from the sea as it is possible to get in Britain – I am still drawn towards the sea; my favourite pictures always include water. It could be a calm turquoise tropical sea, a wild turbulent Atlantic complete with stormy skies or a burning orange sunset in a murky dark sea – I love them all.

The best advice in thinking about seascapes is to take photos at every opportunity, taking several as the light can change so quickly. Clouds can suddenly appear and change the sea from aquamarine to a dull grey. When you see the results, you can be pleasantly surprised when you find the one magical picture with colours that demand to be worked with – one for the sketchbook!

Another way to look at your landscape is from different angles. Place an isolator window (an empty frame that you hold in front of you to see what will fall within your picture's field of view) over your image, so you can frame a perfect and well-balanced picture. Keep features such as trees and houses to the sides and leave your centre peaceful.

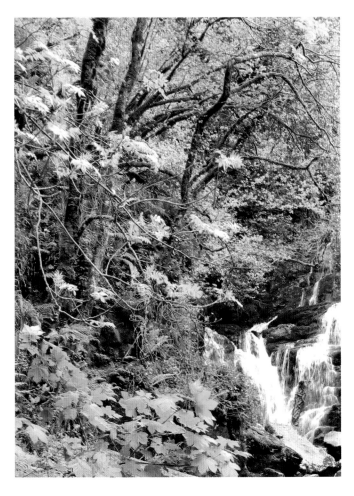

Above: Torc Waterfall in Killarney, Ireland. The brown rocks surrounded by rich green foliage and divided by glistening foliage give plenty of contrast.

Right: Using an isolator window will help you to select an area of interest which can be used to explore further design possibilities.

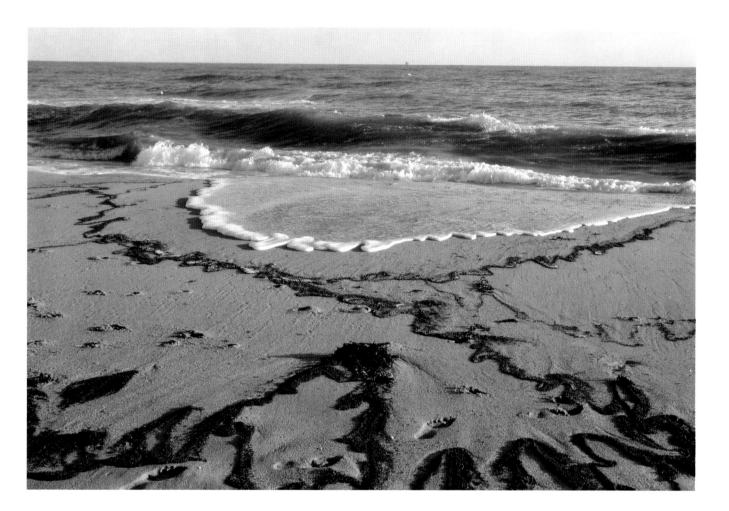

Above: Beach in Jard-sur-Mer, France. The waves crashing onto the beach leave a multitude of foam and seaweed patterns.
Right: **Sketchbook** *(Christine Slade). Ripped strips of magazine pages and watercolour washes are the first step in analyzing shape, colour and line.*

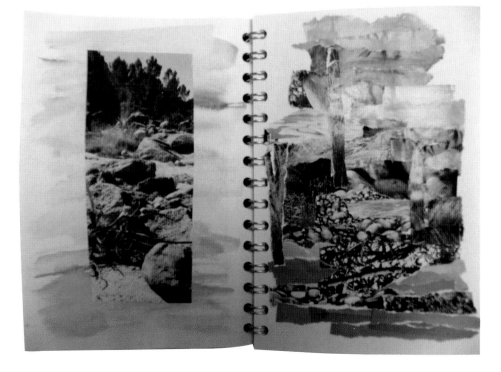

Making and Keeping a Sketchbook

Throughout this book there will be ideas and hints on how to fill the pages of your sketchbook.

Keeping a sketchbook or journal is not only fun but very useful. It will be a unique collection of drawings, impressions and photographs. With the addition of postcards, admission tickets, dried leaves or flowers and a few photographs, your sketchbook will become a fascinating journal of your travels. Start close to home and fill a few pages with pictures, sketches, impressions of colour, a map and perhaps a few words about your local landscape. It will be a helpful tool to refer to time and again, and will help to train your eye. Take a walk, observe your senses, learn to understand and feel nature, recording the smells, the sounds, the temperature and, of course, the view.

You will need a notebook with good-quality plain paper that will take watercolour. In the UK, 'Pink Pig' books are very reasonably priced, ring-bound and covered with colourful handmade paper, and are available in a range of sizes. Personally I prefer to work in an A5-size book (148 x 210mm/5¾ x 8¼in) as it is not too big to keep in your travel bag and it does not take too much time and effort to fill a page. It will also accommodate (sideways) 15 x 10cm (6 x 4in) photographic prints.

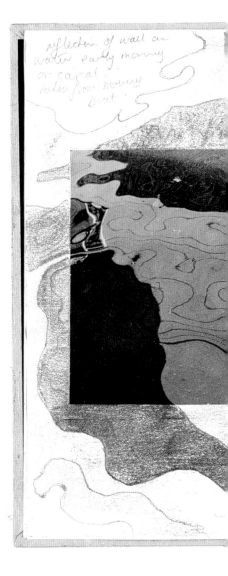

Above: **Sketchbook of Texture and Reflection** *(Judith Hill). A photograph of oil on the surface of a canal was the inspiration for these beautiful sketchbook pages.*

Right: **Thailand sketchbook**. *Simple impressions of a village we stayed in while trekking in Thailand.*

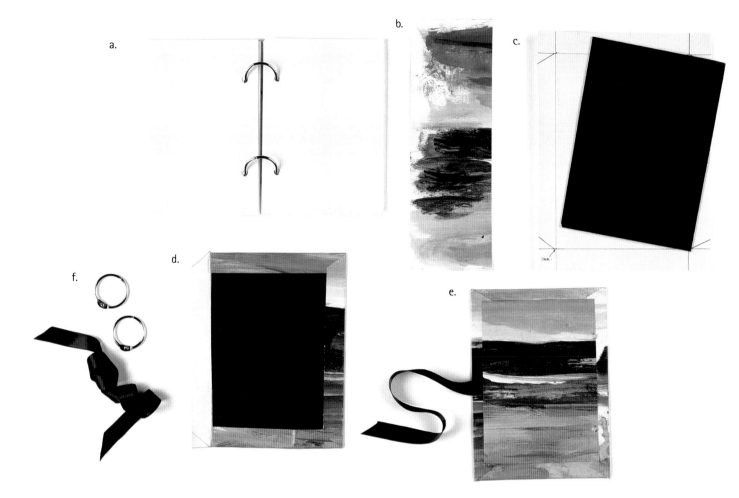

Making your own sketchbook

1. Decide on the size you want your pages to be and cut up sheets of paper to that size. Lining paper is fine, or for better quality use thick cartridge or watercolour paper. Your pages should be large enough so you can punch holes in one edge and fit hinged document rings (a).

2. Cut two rectangles of mount-board – or other thick card – slightly larger than your sketchbook pages to make strong covers.

3. To decorate the covers paint a large sheet of lining paper with acrylic paint, Brusho (a versatile watercolour medium made by Colourcraft Ltd) or ink (b).

4. Now cut two rectangles of your painted cover paper 2cm (¾in) larger all round than the mount-board. Cut another two pieces 5mm (¼in) smaller than the mount-board as endpapers to neaten the insides of the covers.

5. Lay out each of the two larger cover papers face down and place a rectangle of mount-board centrally on top. Draw round the board, using a ruler and pencil. Draw a sloping line on each paper from the inner edge of each corner square to the paper's edge (c). Cut out the squares plus the additional sloping sections.

Above: To make a sketchbook in five easy steps, cut pages to the desired size, punch holes on one side and fit into hinged document rings (a). Paint your cover paper in whatever way you like (b). Cut mount-board covers to size then trim your cover paper to fit (c). Glue the paper to the mount-board (d), add ribbon ties and neaten the inside of the covers with endpapers (e). Assemble your finished sketchbook. Full details are given above right. Right: The finished sketchbook, ready to be filled with inspirational ideas.

6. Paste the wrong side of each large cover paper with PVA glue (white craft glue), starting in the middle and working to the edges.

7. Position the board back on the paper then fold and stick the edges of the paper over the board, starting with the top and bottom edges (d).

8. If desired, cut two short strips of ribbon to use as a tie. Place one on the back of each board (on opposite sides) then paste an endpaper on top, trapping the ribbon (e). Leave the covers to dry, weighted under some heavy books.

9. Punch holes in the covers and pages and assemble your sketchbook, using hinged document rings to secure the pages in the book.

It is a good idea to record the date and place of your first entry on the front page for future reference. In years to come you can look back and track your progress.

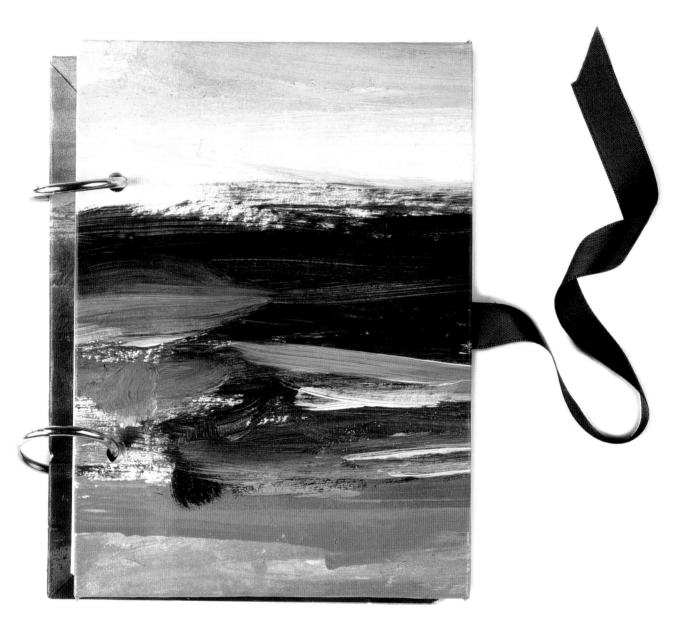

Project: Filling in the Gap

You will need:
- A colour copy of a photograph for inspiration
- Coloured pencils
- Watercolours
- Glue stick

1. Make a colour photocopy of the landscape picture you love and would like to work with. Cut it in half lengthways and stick it on a clean white page of your sketchbook, leaving about 25mm (1in) of space between the two parts.

2. Start filling in the gap with coloured pencils, extending the landscape features as necessary and trying to get as close as you can to the colours of the photograph – ideally you should not be able to tell where the picture was cut. This exercise will make you look at the colours properly. You will be surprised at how deep they really are. Write down the colours you have used, and make a chart ranging them from the lightest to the darkest.

3. Now move on to the watercolours and repeat the same selection of colours on another page. While the paint is wet, colours will run into one another and create all kinds of unusual effects. If you wait until they are dry they can be overpainted with a darker shade, or blended with another colour. With practice and patience beautiful impressions of landscapes can be created. You can move outside, sit in the garden (or the landscape itself!) and try to interpret the colours you see in a similar way.

These first impressions of colour, done instinctively, are often the best, and can be used as the basis of a new piece of work.

Above: Big brushstrokes of watercolour will give a quick impression of a landscape.

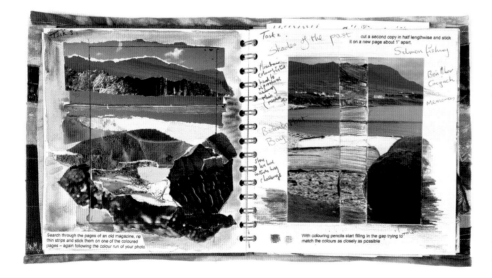

Left: **Sketchbook** *(Judith Hill). These pages show an exploration of a landscape photograph using ripped-up magazine pages and a filling-in-the-gap exercise. She has also added words expressing what the landscape means to her.*

Right: **Achiltibuie, Scotland 2** *(Judith Hill). Ripped strips ironed onto dyed fusible wadding and embellished with a combination of hand and machine stitching. Based on the artist's pictures of Scotland. 33 x 46cm (13 x 18in).*

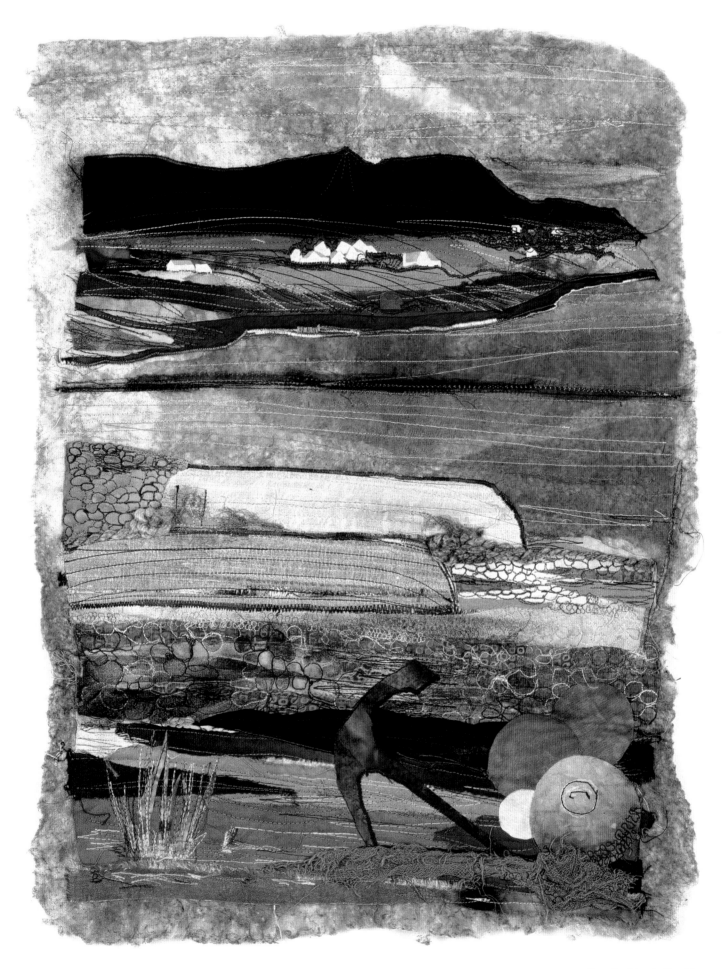

Project: Landscape Cards

Following the previous colour exercise, you can now make a landscape card – a small landscape composition (this one is based on the idea of horizontal bands) on a card-mounted piece of fabric. You will need:

a.

- Folded card with a rectangular aperture cut in it of approximately 50 x 75mm (2 x 3in)
- Piece of greaseproof paper (butcher's paper) or thin Vilene (Pellon), 63 x 88mm (2½ x 3½in).
- Strips of fabric, approximately 100mm (4in) long
- Two pins
- Needle and thread or sewing machine
- Scissors
- Masking tape

b.

1. Trace the pattern lines of your desired landscape image onto the greaseproof paper or thin Vilene (Pellon). You can design your own, but strips should be no wider than 6mm (¼in) and lines don't need to run parallel (a, right).

2. Sort thin strips of fabrics in your chosen colours – no more than 8 or 10 (b, right). Top and bottom strips should be about 38mm (1½in) wide to incorporate a small seam allowance.

e.

c.

d.

Above: To create a landscape card in five easy steps, first draw out your design on greaseproof paper or Vilene so it fits in the aperture of your card (a). Sew two strips of fabric together, following your design lines (b). Continue in the same way, leaving the edges of the fabric showing or stitching them neatly (c) until you reach the top (d). Add a focal point such as a house or trees. Neaten the edges of the design then stick it behind the card aperture to finish (e). Full details are given opposite.

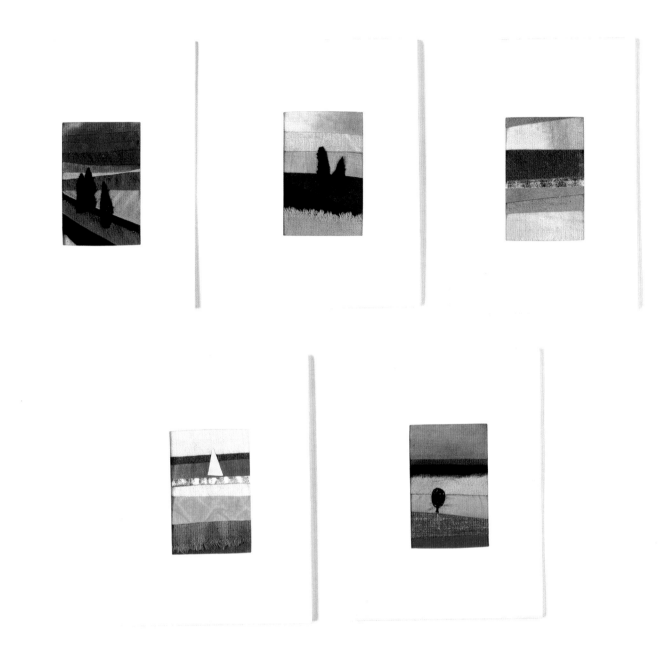

Above: Samples of various landscape cards. Note that the addition of a focal point such as a tree or sail will immediately give your landscape impact.

3. Pin the first strip onto your paper or Vilene – remember to add a seam allowance. Take your second strip of fabric and pin right sides together, then sew these first strips onto the paper (c, left). Remove the pins as you work.

4. Leave the needle and thread on the back of the paper and trim any excess fabric off the seams to 6mm (¼inch), finger-pressing towards the top. Choose your next colour and either pin to the previous piece with right sides together or, to add a bit of texture, with the frayed edge showing. Stitch (d, left).

5. Pick your next fabric and make a couple of stitches upwards, then sew in the other direction across. Repeat this process until you reach the top. You can stitch around the outside to secure all the edges. There is no need to take the paper out.

6. If your mini-landscape requires a focal point you can stitch or stick one or two trees on, a house, maybe a sail on the sea, a bird in the sky or simply a sun. Trim the edges neatly – be careful not to cut your stitches – and stick the landscape behind the opening in the card with masking tape to finish (e, left).

Fabric Postcards

A relatively new and very popular way of doing a fast and furious landscape is to make an actual postcard, on which you can stick an ordinary self-adhesive stamp so it can be sent through the postal system.

To do this, you will need:
- A 150 x 100mm (6 x 4in) piece of Hobbs Heirloom 80/20 fusible wadding or any other wadding/fabric that can be fused with Bondaweb (Wonder Under) or spray glue
- Backing fabric of a similar size to the wadding
- Strips of cut and ripped fabrics, papers etc.
- Greaseproof paper (butcher's paper)
- Bondaweb or Wonder Under
- Iron and board
- Threads

1. After choosing your design, rip or cut strips of fabrics of widths that vary in approximately 13mm ($\frac{1}{2}$in) increments up to 50mm (2in) the same width of your piece of wadding – either 11cm (4$\frac{1}{2}$in) in length for portrait orientation or 16cm (6$\frac{1}{2}$in) long for landscape.

2. Start to build your chosen picture with the various strips of fabric; keep it simple and try to use no more than ten. Place the wider strips at the top and bottom, then narrower and darker strips going up towards the horizon. Think about where you want the horizon and use a nice straight strip for this. Start the sky above the horizon quite light in colour and using wider strips, getting darker towards the top again. Sometimes one good indigo-dyed piece of fabric will do the whole sky.

3. When you're happy with your composition, place pieces of greaseproof paper on top and underneath, then iron the layers together. Remember that fusible wadding sticks on both sides. If some parts haven't fused, use a strip of Bondaweb.

4. You are now ready to quilt your layers together. Keep stitches simple and use a co-ordinating thread. Machine stitching can be added later. You can add a focal point or other bits of interest in the shape of, say, a tree, house, beach-hut, sun, sail, bird or a couple of hills. These can be fused on by first cutting them out of fabric backed by Bondaweb, then peeling off the paper and ironing into place. A few machine stitches can be added to secure these into place properly. Finally, iron the backing fabric with postcard lines onto the back of your mini-quilt, tidy the sides with a ruler and rotary cutter, and finish the edges by hand with a blanket stitch, or satin-stitch by machine.

Above: A selection of fabric postcards. The one on the left is a work in progress.

made by Ineke Berlyn

Colour and Fabric

'Now I really feel the landscape, I can be bold and include every tone of blue and pink: it's enchanting, it's delicious.'

Claude Monet

I am very passionate about colour; I just love working with a bright spectrum of colours. Colour fills the world around us: sky, sea, earth and fire all sparkle with brilliant colour.

My best days are those spent dyeing yards of calico and cotton thread, and the sight of a dazzling line of washing always fills me with great delight. It makes me reach for the camera every time, and the results are always bright and always different. Then, when it's all dry, it's the most enjoyable ironing I do.

Some artists have a natural feel for colour; they know instinctively where to put which colour in a composition, what shade, which tone – and they know which colour is needed to pull a whole picture together. Don't worry if you haven't got this gift; you can always learn it. The most useful tool available is the colour wheel, and if used consistently – but also occasionally ignored, just to see what happens – with practice, practice and more practice you will learn how to use colour effectively and even spectacularly.

So where do we start?

Above: Dyed squares of fabric drying in the sun.

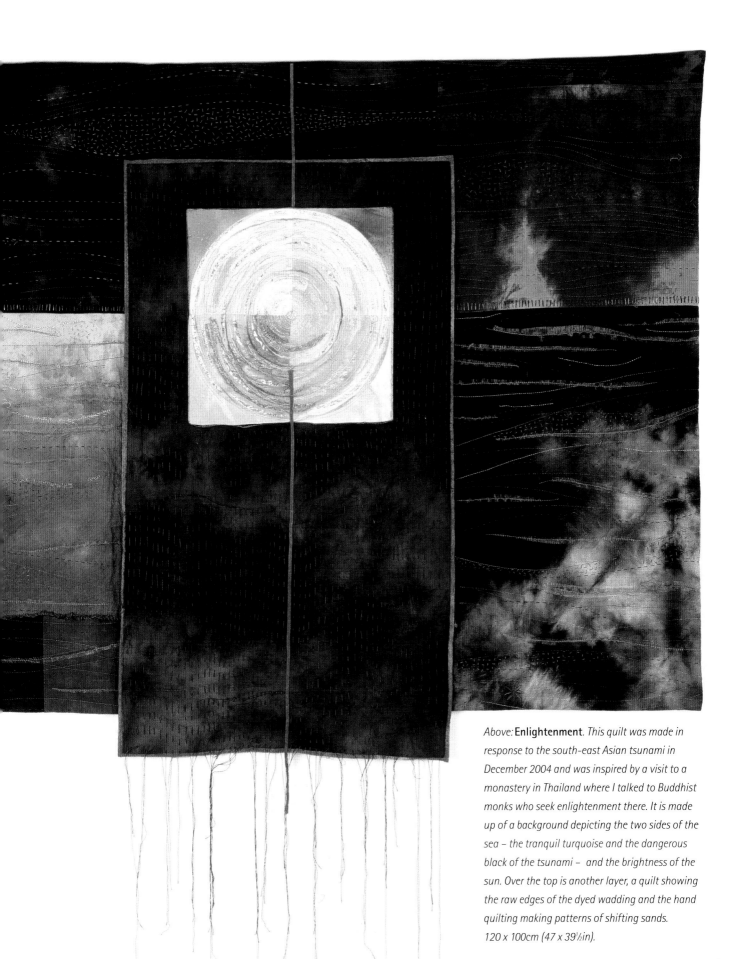

Above: **Enlightenment**. *This quilt was made in response to the south-east Asian tsunami in December 2004 and was inspired by a visit to a monastery in Thailand where I talked to Buddhist monks who seek enlightenment there. It is made up of a background depicting the two sides of the sea – the tranquil turquoise and the dangerous black of the tsunami – and the brightness of the sun. Over the top is another layer, a quilt showing the raw edges of the dyed wadding and the hand quilting making patterns of shifting sands. 120 x 100cm (47 x 39½in).*

The Colour Wheel

Anything to do with colour will have to start with the colour wheel. This is the logical tool to find out where the colours come from, which ones go together and which ones (allegedly) clash!

All colours (except black and white) come from mixtures of three pure primary colours, which for a subtractive process such as mixing paints are blue, red and yellow (additive processes such as colour photography have a different set of primaries). These are the three 'source' colours, and the relationships they have with each other are represented in the colour wheel.

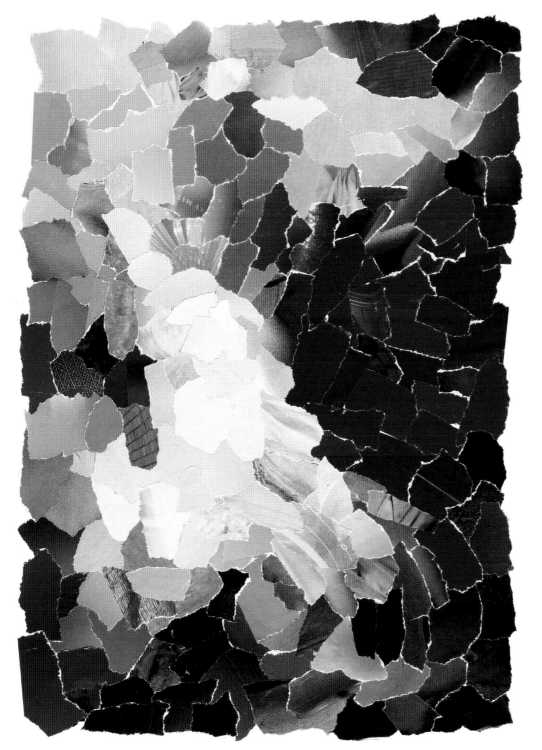

Left: Colour wheel made from magazine cuttings (Lynne Hume).

By mixing two primary colours you get a secondary colour:

Blue and yellow make green.

Yellow and red make orange.

Red and blue make violet.

The colours that appear opposite each other on the wheel are called complementary colours. Pairs of complementary colours include blue and orange, yellow and violet, and red and green.

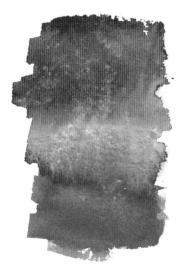

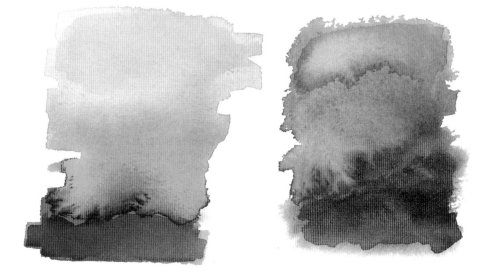

An interesting experiment is to gaze for some time at this fuchsia-red square and then close your eyes. The square you see as an after-image will be a green square.

Repeat this exercise with any colour, and the colour you see afterwards will always be its complementary colour.

Then there are the neutral colours – black, white and grey – which lie outside the range of hues that can be produced by any mixture of the subtractive primaries. These dull colours are used to make the bright ones sparkle in comparison.

To understand colour better, it is a good idea to make your own colour wheel in your sketchbook, initially using materials that are at hand, such as colouring pencils, watercolour, inks or acrylic paint. Start with the primaries, then mix in the ones in between. An interesting way to practise your colour knowledge is to use pictures of landscapes (they can be photographs you've taken, or pictures cut out of magazines) and try to build up a colour wheel out of those.

Colour Values

The next step is to take a look at the 'value' of each colour. Lighter colours advance (seem to come forward in a picture) while darker ones retreat into the distance. A very light area will appear much closer when it is surrounded by darks. A bright pink will look much brighter on black than it does on white.

Left: Experiments in watercolour showing different values in colour from dark to light.

An experiment to help you think about colour values is to put a strip of blue (as a dark-value colour) and a strip of white (a light-value colour) on a medium-value background such as gold. If you then look at the blue you will notice that the gold colour surrounding the blue strip appears darker than the gold around the white strip. It is our brain that creates this effect.

An appreciation of colour values is an important aspect of choosing the colours, and their tones, that you will use in your picture. To make our eye travel to the bright postcard centre we are creating in our landscape quilts, it needs to be surrounded by the much darker shades of dark green, navy, purple, brown and black. Putting a dark frame around your finished piece will set if off even better.

Another excellent way of looking at colour values is to make a black-and-white photocopy of your source photograph, or your work. This monochromatic interpretation will show you exactly where the light, medium and dark values are. These contrasts in value will help to create a sense of depth in your quilt. Another useful trick to note when choosing the colours for your wall hanging is to first place your pieces of fabric onto a black or very dark background before stitching them together.

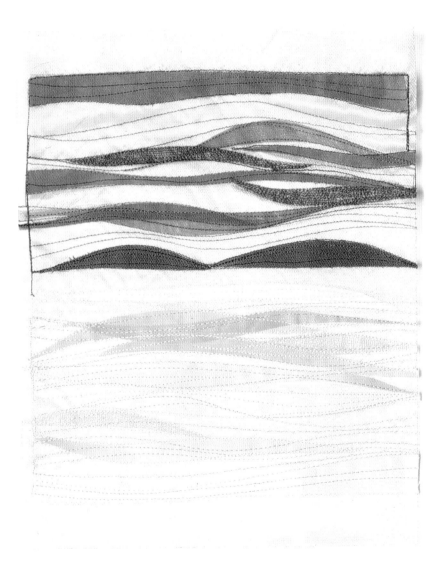

Right: **Summer/Winter**. *A double-sided sheer piece with yellow fields of corn and brooding skies on this side and a snow-covered landscape on the reverse (not shown). 20 x 21cm (7¾ x 8in).*

You can also experiment with different juxtapositions of colour by, for instance, cutting twelve 25mm (1in) squares of one primary colour, such as cerise red, and gluing or stitching them on 75mm (3in) squares of twelve different colours, as shown right.

A natural progression for anyone working with textiles is to take this process one step further and dye batches of material representing the whole of the spectrum in the colour wheel. If you make your wheel from this, you will not only have a useful reference of the relationships between different colours, but at the same time you will have created a fantastic supply of coloured fabrics representing every colour on your wheel.

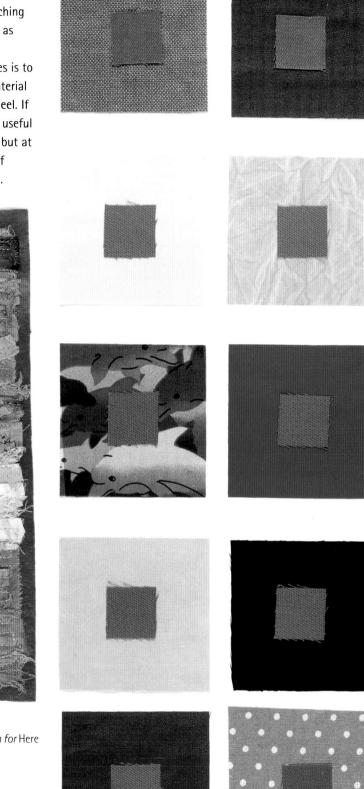

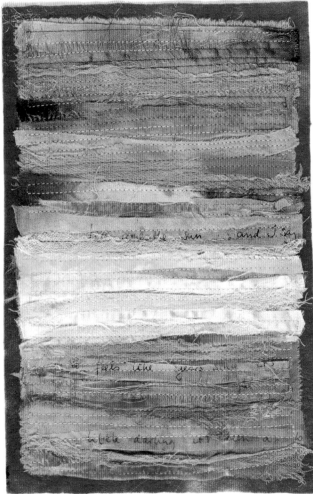

Above: **Small yellow to red sample.** *A small study in preparation for* Here Comes the Sun *(page 55). 20 x 30cm (8 x 12in).*

Right: This colour exercise shows the interaction between one colour and various different backgrounds.

Materials For Colouring

Watercolour Paints and Pencils

Putting the first splash of colour on that first glaringly white page of a new sketchbook can be quite daunting, so why not start by putting a watercolour wash on it using water, a wide brush and a simple set of children's watercolours. As you're getting more familiar with this medium you can progress to a handy pocket-size set of watercolours. They contain about a dozen basic colours, from which many more can be created. Then there are watercolour pencils; you can colour with these, but they can also be blended with a small paintbrush and water. A traditional set of colouring pencils, such as those made by Crayola, is another economical way to put pencil to paper and start playing with colour. They too can be mixed and blended to create many hues and tints.

Acrylic Paint

Acrylic is a medium that will give a stronger, thicker and deeper colour. It dries quickly – in about five minutes – with a glossy finish, and it can also be thinned with water or special mediums. Mixed with a textile medium it will become colourfast and can be used to print on fabric. Once dry, acrylic colours cannot be re-wetted, and therefore you have to make sure your brushes are kept clean or immersed in water.

Fabric Paint

Fabric paints, such as Setacolor paints, can be painted or printed straight onto fabric without the need to add a fabric medium. They will need to be heat-fixed according to the instructions or, when using Setacolor, a hot sun will set the colour as well. Fabric paints will give you the opportunity to use items such as leaves, flowers and feathers as resist templates on the painted material, and to create your own colourful fabric using the smaller patterns found in the landscape.

Oil Paint

Although oil paints are not very suitable for using in your sketchbook, the fact that they take a long time to dry means they can be used effectively in printing with the smaller parts of the landscape, such as grasses and leaves on papers, fabrics, sheers or organzas.

As an exercise in using some of these media, pick some grasses and leaves when you are out for a walk (autumn is an ideal time, since you can pick up some brilliantly coloured leaves on a walk in the woods).

Start with a smallish leaf, and with a soft brush cover one side thoroughly with oil paint. Then press the painted side of the leaf onto your paper or fabric and (to avoid smudging) place a piece of tissue paper over the untreated side and rub gently. The result is a very fine and detailed print that can be coloured over with watercolour, ink or dye – a stunning piece of nature art created simply by printing with your finds.

When printed on polyester sheers or silk organza you can use these leaf and grass prints as an extra layer in your landscape quilt; and they are particularly good for the transparent landscapes further on in the book.

The Character of Colours

I will look first at white and black, and then the other colours in the order in which they appear in the rainbow, that visual feast of nature.

White

White is pure. It is our bare canvas. It is what we start off with before we add any colour. It is the snow that turns our colourful world into a monochromatic one. It is the Cliffs of Dover. In art, white is minimalist and modern, the colour of galleries. White is never *only* white though: a white sky is often tinged with grey or pink, and a white linen tablecloth in time becomes cream.

I have a slight obsession with white. Whenever I go to an antique market, charity shop or car-boot sale I cannot stop myself buying old linen tablecloths, napkins, sheets or embroidered cotton pillowcases. Not only do they all take Procion dye beautifully, but used in their multitude of shades, they make gorgeous little pieces of textile art or large heirloom quilts.

Black

Black can be either bluish-cool or reddish-warm, and is the neutral we need to set off all those brilliant colours. It is also the most difficult colour to dye. No colouring agent will give a perfect black because black absorbs light and no paint or dye can quite achieve perfect absorption. At first, painters mixed a very dark red brown with a dark blue to create black, then in the 18th century indigo and tinctional logwood made a darker black. A hundred years later, the arrival of chromium mordant produced an even richer black to supply the stylish black clothing that was fashionable in the moral and modest 19th century.

Red

Red, and mixtures of red, are typical autumn colours. It is a powerful colour, associated with fire, anger, love and war. The Egyptians used the madder plant to dye the red linen textiles found in the Old Kingdom tombs of the Nile Valley. They also invented mordanting to increase colourfastness. The dried and milled roots of madder mordanted with alum produced many reds and yellows. The shell of the rare cochineal insect provided Europe with another very costly but fine red fabric that could be laundered. But until the 17th century only India knew how to dye cotton red, and dyers in Europe were eager to learn India's secret of 'Turkey red' found in many quilts from that era. Madder red was a very popular colour for woollen military uniforms, looking good on parade and, when in battle, handy for hiding the bloodstains!

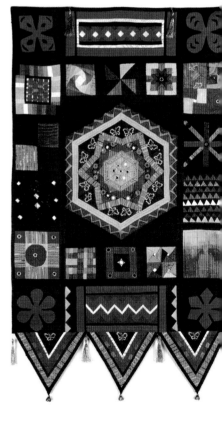

Above: **Indian Spice.** *Inspired by the hot colours of the East, this wall hanging shows samples of the many fabric-manipulation techniques that exist. 73 x 130cm (28¾ x 51in).*

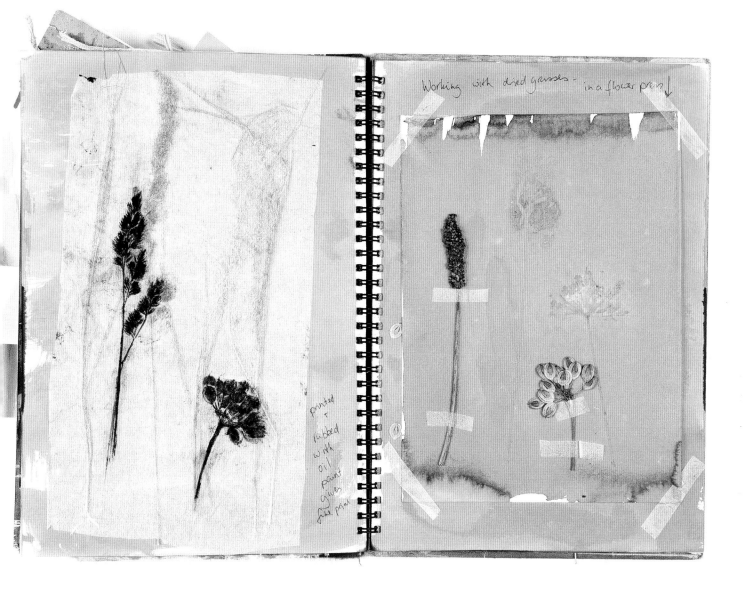

Working with dried grasses - in a flower press↓

printed
+
rubbed
with
oil
paint
gives
the print

Above: This sketchbook contains the inspiration for many of my journal pages and sheer pieces. It has some very colourful pages.

Right: The whiteness of snow lends a sense of purity to a landscape.

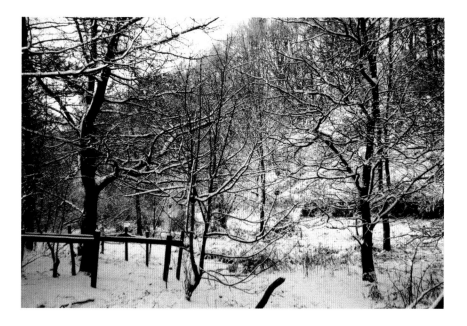

Yellow

'There are painters who transform the sun into a yellow spot, but there are others who, thanks to their art and their intelligence, transform a yellow spot into the sun.'

Pablo Picasso

Yellow is the colour of summer, associated with sunshine and happiness. It's a colour that can be valued as cool – when a little blue is added – or warm, when mixed with red to make orange.

The oldest-known dyed fabric dates back to around 6000 BC, and was yellow. Seeds of weld and saffron were used by the Egyptians and Romans to dye cottons yellow. In nature there are quite a few herbs and plants that will make yellow, such as chamomile, elder leaves, dahlias and broom, so it has always been a relatively easy colour to dye.

A very bright lemon yellow with a hint of green can appear cold, but add a bit of orange and the warmth will spread. There are many shades and names of yellow: besides lemon there is cadmium, the standard bright golden hue for brilliant sunshine, and warm, muted yellow ochre. Ochre or iron oxide is the oldest colour in the palette. Humans first dug it out of the landscape more than forty thousand years ago. The word means 'pale yellow' in Greek, but nowadays it is used to describe the shades between rusty red and yellow. It is perfect for those earthy tones in landscapes, and when mixed with a bit of blue produces soft muted greens. When mixing in a bit of red you can get a fresh tangerine orange or a deeper reddish orange.

Yellow is not everyone's favourite colour – and I admit some shades can be quite harsh, especially those fluorescent yellows that you almost need to take a step back from. But I have spent many happy days mixing yellow with reds, purples, blues and greens and pouring it onto all kinds of different-textured fabrics – calico, linen, silk, satin, viscose velvet and scrim – giving me a huge stash of fabrics to start work with.

After I was first inspired to start working in yellow, my first, small piece – *Yellow Tulips* – was inspired by the poppies that are a central theme of the English artist Laura Kemshall's work, the yellow-based pieces of the Dutch artist Jette Clover, and my own favourite tulip lino print.

Next came *Enlightenment* (shown on page 45), inspired by an image of the sun in an early work of Ton Schulten and a visit to meet young priests at a Buddhist temple in Thailand. The student Buddhist priests wear robes of yellow to reflects the light of nature; their teachers wear orange to symbolize the idea of this light glowing from within. Their philosophy on life is to seek true enlightenment. So my next step was to make a truly yellow piece. This was *Here Comes the Sun* (opposite), which was a follow-up to *Enlightenment* and also a complete exploration of shades of yellow. While I work, I often listen to the radio, and one of my favourite songs with happy memories is 'Here Comes the Sun' by George Harrison, whose outlook on life had much in common with the yellow-robed Buddhists of Thailand. As I was singing along I realized the lyrics were perfect for this piece and made this hanging complete. I stamped the words on using acrylic paint and a set of small alphabet stamps.

Left: **Here Comes the Sun**. *This detail shows the intense colour gradation and stitching in this piece.*

Right: **Here Comes the Sun**. *A follow-up to* Enlightenment *(page 45) and the desire to truly explore the colour yellow. The words of the George Harrison song 'Here Comes the Sun' are included in the piece. 100 x 155cm (39½ x 61in).*

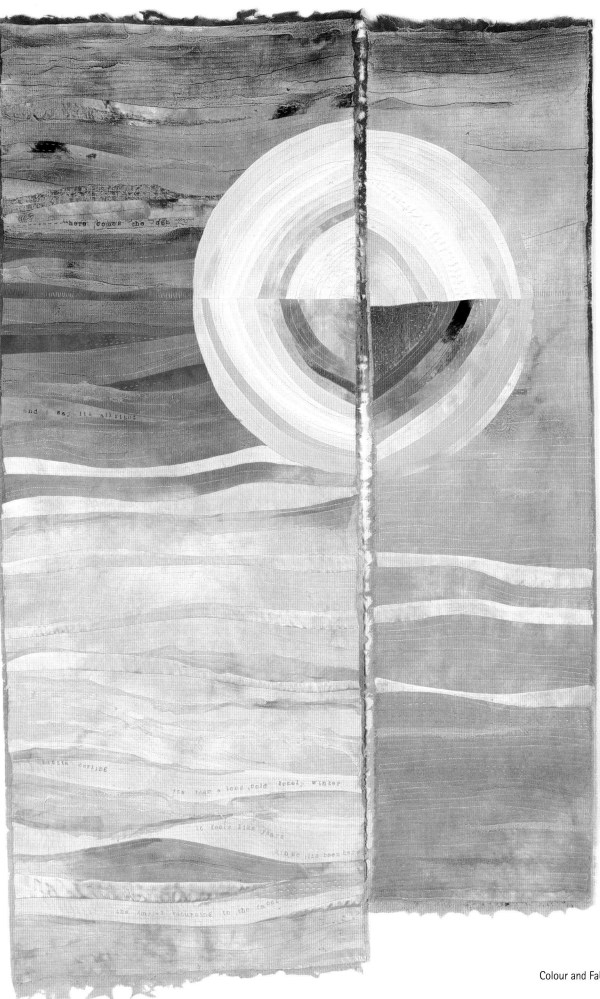

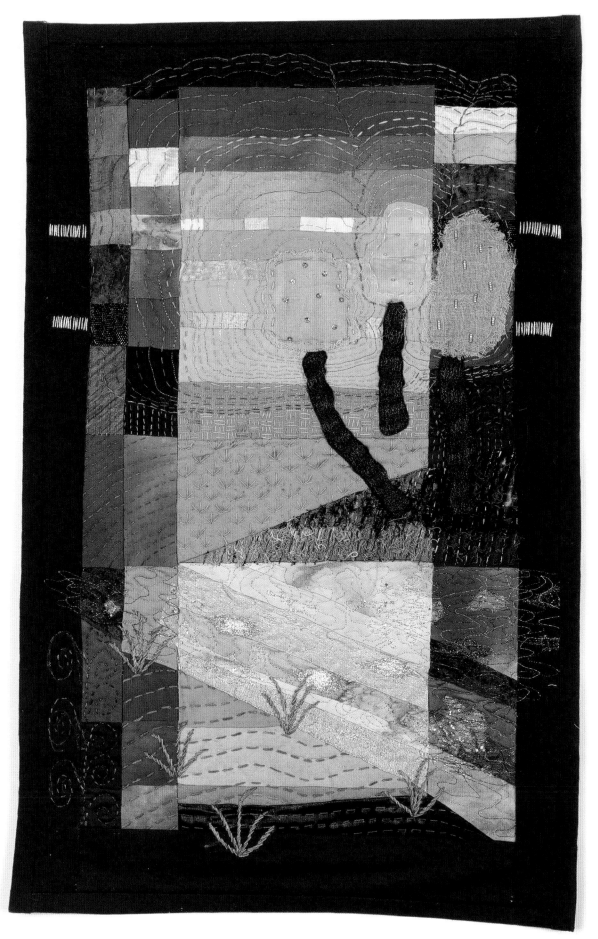

Green

Green is the colour of grass, trees and fields; it is the first colour you associate with landscapes. Most of the natural world (on land, at least) is green. Yet it is one of the most difficult colours to reproduce. Green plants do not make green dyestuffs. Weld produces a yellow dye, woad will make a blue and *together* they will make green, but there is not one plant that dyes a true green. It was not until the late nineteenth century that a good synthetic green dye was discovered.

Kermit the Frog sang 'It ain't easy bein' green', and I agree with him. I find it a very difficult colour to get the right shade or tone. This is partly because it lies right in the centre of the range of light frequencies that our eyes can see, meaning we are sensitive to finer gradations of shade in green than with the colours at either end of the spectrum.

Invaluable in landscape quilts, green is composed of blue and yellow. The darker shades are easy to work with – great for making a yellow sparkle, or for muting a red. Then again, combine a lime green with a raspberry red and you have a delicious bright and fresh combination often used and seen in the garden.

Left: **Green Landscape** *(Janet Carpenter).*
Abstract landscape of fresh green trees by a turquoise pond. 36 x 56cm (14 x 22in).

Right: Many shades of green can be found in your own garden.

Blue

The colour of the sky, blue is the colour that creates space in a picture because it goes further than the seas and the horizon, reaching into the distance.

Blue is a cool but very strong colour in the spectrum – useful qualities for such essential design elements in your landscape quilt as skies and water. Indigo dyeing gives many natural shades of blue, but other more vibrant blues include ultramarine, cobalt, cerulean, Prussian and turquoise.

Why is the sky blue? The light rays from the sun are made up of the full range of colours in the spectrum, but the only wavelengths we can see are the ones reflected by clouds or moisture. The brightest reds and yellows travel through the atmosphere almost unaffected, but the smaller wavelengths of blue and violet light are scattered by the molecules of oxygen and nitrogen in the atmosphere and are the ones seen by the human eye as blue. When the sun is near the horizon, setting or rising, its rays have to travel through more of the atmosphere to reach us, and blue light peters out near the horizon, leaving only the longer wavelength yellow, oranges and reds, and giving sunsets their characteristic colour. Dust or moisture particles from pollution or natural causes also scatter shorter wavelengths, exaggerating the redness of the sky at sunset.

Above: Shades of blue on a Caribbean beach.

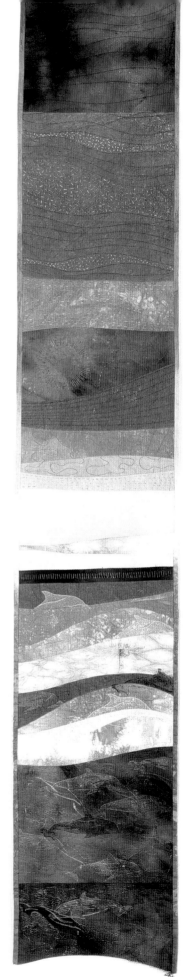

Right: **Long Indigo Seascape**. *A range of different indigo-dyed fabrics are pieced with curves. As the indigo dye vat loses its strength, the colour gradually gets lighter. Dolphins are printed on with lino-cuts and the quilting is a combination of hand and machine. 25 x 145cm (10 x 57in).*

Indigo

Indigo blue originated from India, but in Europe woad provided the base of most blue dyes until recent centuries. It was an elaborate process and could only produce a washed-out blue, which was used for work clothes. It was not until the end of the 12th century that Europeans discovered a technique for making brighter blues, and a taste for privileged 'royal' blue developed. A hundred years later, a much superior blue, 'indigo', was imported from India – the word actually means 'from India' – and by the 19th century British factories using indigo dyestuffs from India made Britain one of the foremost producers of blue fabrics in the world.

Below: **Indigo Blue**. *A patchwork of different white fabrics are free-machine quilted and then dipped in a bucket of indigo dye. 40 x 50cm (15¾ x 19¾in).*

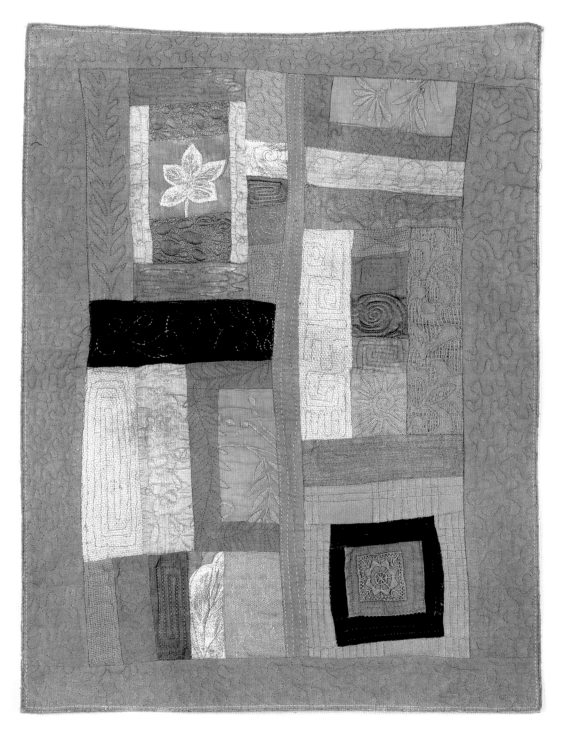

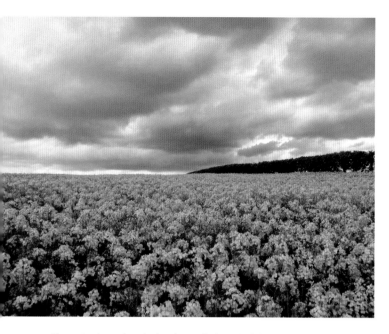

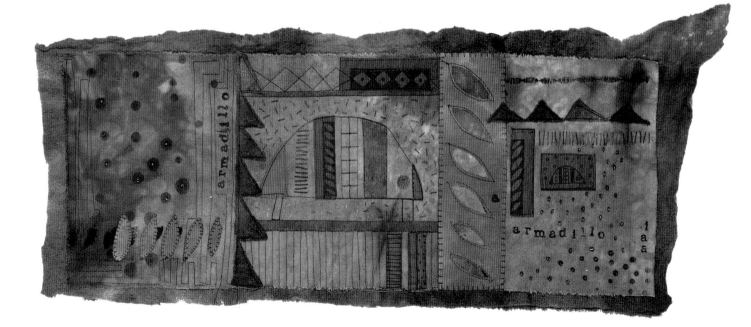

Purple

Historically, purple has been the most precious and sought-after colour for fabrics. The Roman emperors reserved for themselves the right to wear clothes dyed purple, as it was very expensive to produce. It took the ground shells of nearly 10,000 Mediterranean molluscs to make just one gram of dye. It wasn't until 1853 that a teenager in Britain, called William Henry Perkin, discovered a chemical that coloured wool and silk a beautiful violet. The chemical was based on coal tar, an organic substance that originates from fossilized trees, thus giving us still a connection with the landscape. It gained Perkin the patronage of Queen Victoria – who wore her purple dress with pride to the opening of the International Exhibition in London in 1862. The colour was also taken up by the chocolate manufacturer Cadbury when they received the Royal Warrant as suppliers to Queen Victoria, and they wrap their chocolate bars in purple to this day!

The complementary colour of yellow is purple. Now take a look at this picture of the rape fields and the dark blue-purple sky above it – think of it as nature's interpretation of the colour wheel. If you were going to paint this picture, you might gradually mix the yellows and purples, finding that they produce the olive greens of the trees and shrubs in between.

Above: In the spring the landscape is dotted with these bright yellow fields of rape. I took this picture on a day with heavy, angry skies to get that sharp contrast.

Opposite page: A painting by Ian Elliot and the rapeseed photograph formed the basis of this design board in yellow and purple. It shows swatches of fabric dyed in a colour-run, complete with threads and bits of scrim that were dyed at the same time.

Below: **Armadillo**. *A workshop-challenge square of fabric printed with an armadillo was the inspiration for this fun piece of work, playing with purple and pink. 50 x 20cm (19½ x 8in).*

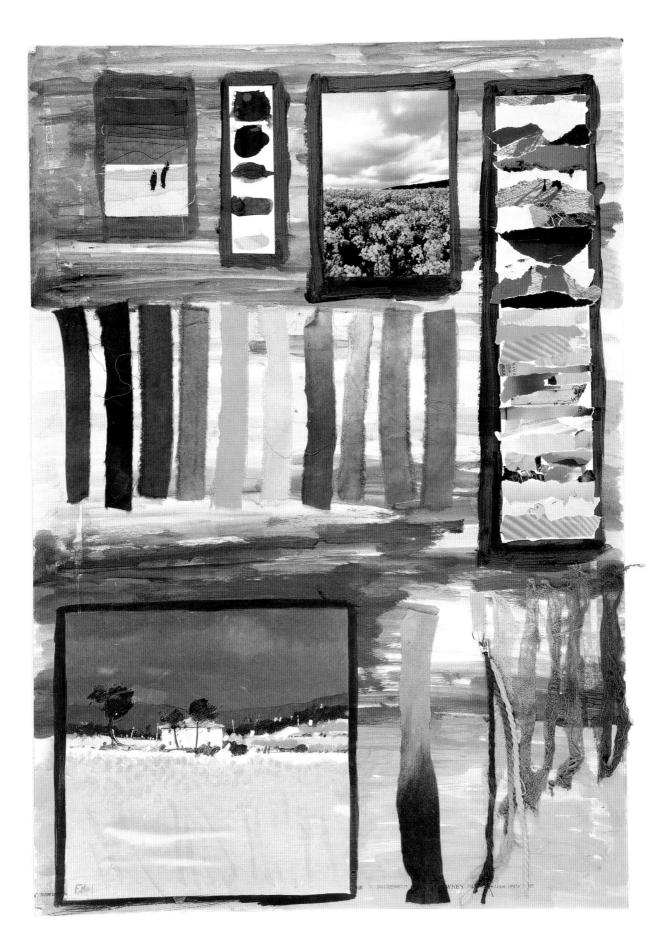

Colours and the Seasons

As the subject of this book is landscapes we have to consider nature very closely, and the seasons and colours associated with each particular time of the year. As an artist you will notice that nature is very clever in balancing colours. The colours of the landscape almost always seem to be working very well together and everything seems to balance naturally.

Spring

The season of new life and fresh growth – green is the colour that springs to mind. The greens will be clear and bright, like lime and apples against whites and yellow.

There is a very picturesque village in Holland called Staphorst, where some women still wear local traditional costume, which dates back to the 16th century. In all the farmhouses of this village, the shutters, window frames, doors, milk racks, gates – anything that could possibly be painted – are all painted in vibrant green, turquoise and white – colours meaning new life.

The colours of the fabrics worn as part of the local dress all have a very deep meaning. In happy times the colours correspond with those we associate with happiness, like red, yellow, bright blue and green. When someone dies black is worn as a sign of mourning. After a certain period of time, and depending on how close your relationship was to the deceased, certain colours are added to the dress – in Staphorst blue is added first, then green, and eventually red and yellow. If the deceased was your husband, you will wear black forever. In the old fishing village of Spakenburg, 40 mile southeast of Amsterdam, the ladies can wear three different colourways. For deep mourning, a lady will wear black and purple for seven to twelve weeks, then later on she chooses white with pale-blue flowers. When out of mourning the bold, bright patterns of bodices made out of Indian chintz shows that happy times have arrived.

Another spring tradition associated with Holland is the arrival of the tulips. Nature excels itself here with an absolute riot of fresh yellows, oranges, reds and purples, giving us a constant source of happy inspiration.

Right: **Tulips**. *These tulips were printed with lino-cuts. The lino cuttings were made from sketches of the three phases of the life of a tulip. They were used over and over again, printed with acrylic paint on hand-dyed fabric. The stems are stencilled on with Markal oil sticks and iron-on templates cut out of freezer paper. The dyed yellow wadding can be seen on the edges. It is quilted with a combination of simple hand and machine stitching. 24 x 42cm (61 x 16½in).*

Below: Tulips are a source of joy and inspiration for me.

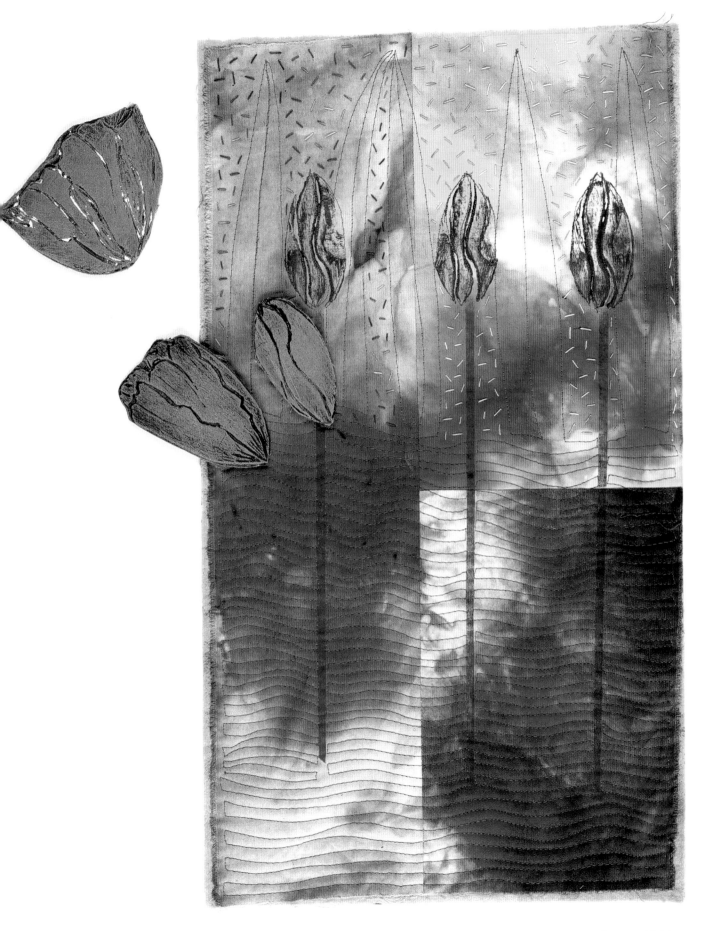

Summer

Summer is the time for warm colours; the gold and ochre-yellow fields of corn, the warm orange sun, the red-hot roses and poppies, the more mature emerald and grassy greens, and the blues of the sky – starting dark indigo looking straight up, smoothing into a warm ultramarine and disappearing into a wispy, pale horizon – while the water of the sea and the lakes reflects a more cobalt shade of blue.

To make all these bright colours work in a summer landscape, you can balance your picture by making use of the longer shadows of this season to add dark, warm browns, purples and deep greens around the outside.

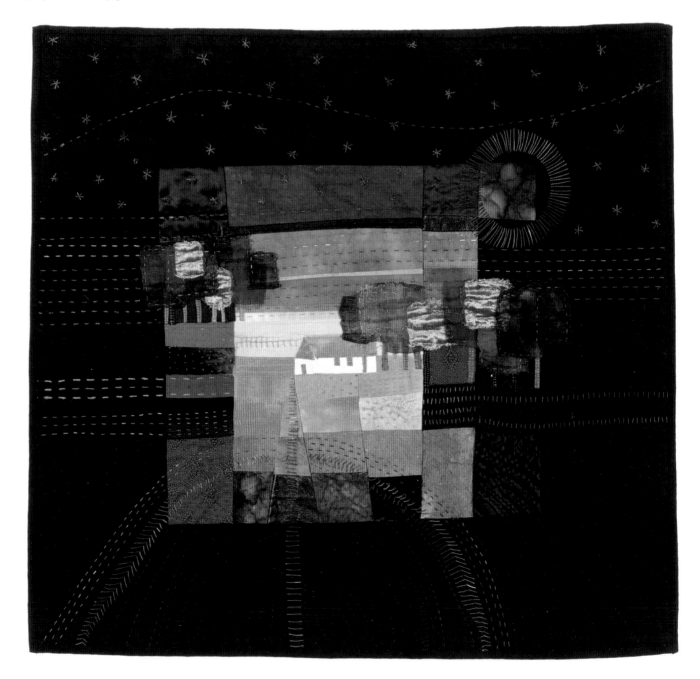

Above: **Summer Fields**. *An abstract landscape using a wide variety of fabrics such as upholstery, leather, velvet, satin lining and old flannel trousers. Houses and trees were applied afterwards, and it was quilted by hand. 54 x 58cm (21 x 23in).*

Autumn

Every year tempting travel pictures of 'New England in the Fall' appear in papers and magazines, but after the occasional hot, dry summer in the UK the colour scheme here can be just as vivid.

The magic of autumn will conjure up wonderful images of forests of rust, cinnamon, gold, orange and rubies – the favourite colour palette of many artists. How often have you walked through musty-smelling woods and picked up leaves in many shades and shapes and thought 'What can I create with this?' Start by putting watercolour washes on your pages, stick in the leaves you have collected with samples of the prints you made with them, add the photographs you took of the forest and put all these together in your sketchbook. It will make a good starting point for a memorable piece of work.

My journal page for October (shown on page 67) was created with just the image shown below right in mind. Simple shapes of trees in glorious colours were caught between two pieces of sheer fabric and machine-quilted with a variegated autumn-coloured thread and added gold highlights.

The idea from my autumnal journal page can be the basis for a landscape through the seasons – taking the tree as a focal point. The following winter season will show spine-like trees on a silver and white background. Spring shows the fresh green shoots of new leaves on the trees surrounded by daffodils and tulips. The height of the summer season shows the trees in full glory surrounded by fields of gold and warm sunshine.

Above and right: Autumn colour at Crimpley Reservoir near Kidderminster, Worcestershire, UK.

Above: **Sketchbook page** *with autumn leaves.*

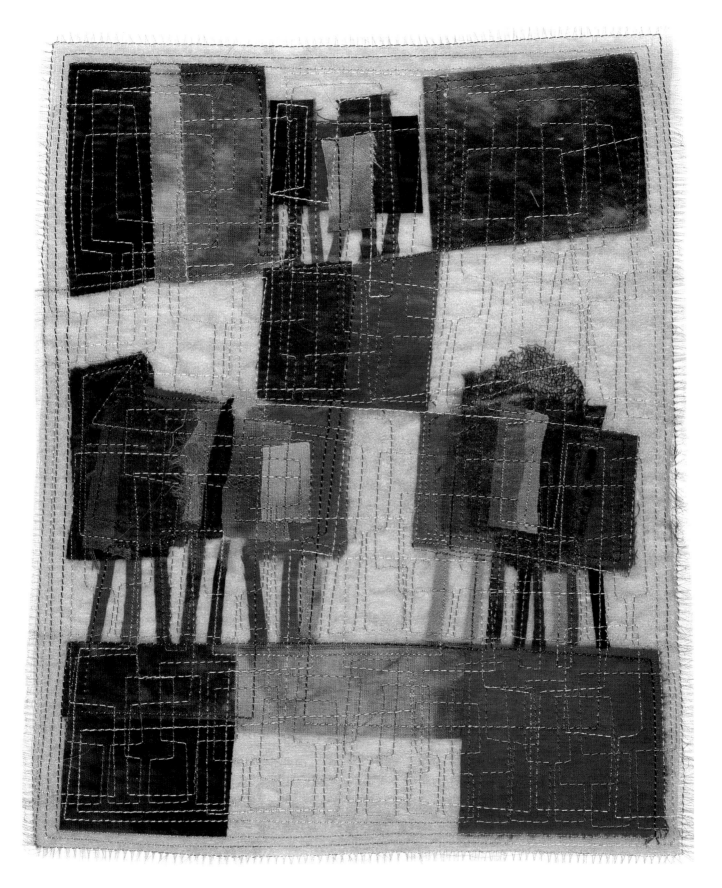

Above: **Autumn Trees**. *A journal piece inspired by the colours of autumn. 24 x 31cm (9½ x 12¼in).*

Winter

White is the cool 'no-colour' we instinctively associate with winter. Your mind immediately goes to Christmas-card scenes of dark trees standing in a snowy landscape. The contrasts are strong but even so, the black can have many shades while the whites can sparkle like silver, or become soft and chalky.

But take another look on a dull and overcast day and you will see all those greys of the stones, the skies and the hills in the distance; and the browns of the trees, the leaves and the soil. Then a sunny day will bring out the blues of a bright sky, the navy of a far forest and the crisp paleness of snow. In between all this, shades of pink and burgundy will appear when the sun will catch some fallen leaves on the ground. And of course there are the greens – but in a more subtle, subdued tone than in summer, with hints of olive, sage and moss. All this makes you realize that winter is full of colour.

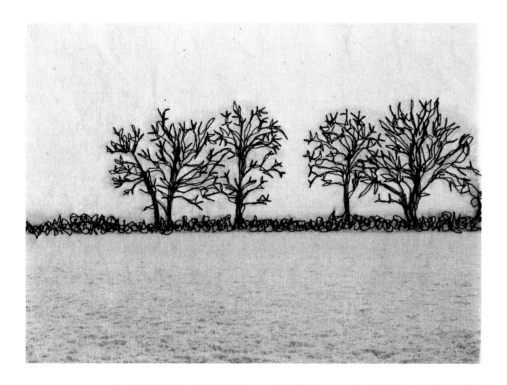

Above: **Icy Trees**. *Photograph printed on calico then free-machine quilted with black thread.*

Right: This photograph of icy trees was used as the basis for the stitched piece shown above.

Project: Dyeing a Colour Wheel

One of the greatest pleasures I get is to dye my own fabric, and once you've dyed your first batch there is no turning back. Besides the health-and-safety instructions, I will have to warn you that it is addictive! With the following simple instructions you can dye a complete colour wheel, giving you a fantastic source of fabrics to work with.

Health and Safety

Before you start please be aware of the following:
- Wear a face mask to avoid breathing in the dye powder dust.
- Wear rubber gloves to avoid contact with your skin.
- Use containers that are only used for dyeing.
- Cover all worktops with protective plastic or paper sheeting.

Materials and Equipment
- Dust mask
- Jugs for measuring water
- Plastic measuring spoons: 3 teaspoons and 2 tablespoons
- Plastic picnic spoons for stirring
- Gloves
- Apron
- Cat-litter tray
- 18 medium-sized strong freezer bags
- 3 jars big enough to hold 570ml (24 fl oz)
- Soda ash
- Procion cold-water dyes in the following colours: magenta, bright blue and lemon yellow
- 4m (4½yd) of 100 per cent cotton calico, medium weight

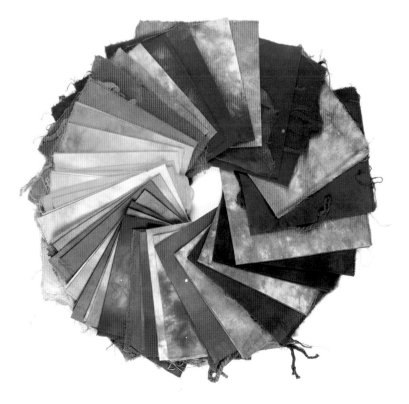

Right: The finished dyed colour wheel.

1. Start by cutting or ripping your fabric into 40 squares of about 300–380mm (12–15in) and a couple of long strips approximately 300mm (12in) wide.

2. Dissolve 240 millilitres (1 cup) of soda ash in a bucket containing 4.5 litres (1 gallon) of hot water and soak the fabric in it for at least 1 hour. I like to prepare this the night before and leave everything to soak overnight.

3. Mix your dyes as follows:

- 3 teaspoons of magenta in a tablespoon of hot water. Stir to dissolve powder completely and top up to 680 millilitres (24 fluid ounces).

- 5 teaspoons of blue in a tablespoon of hot water. Stir to dissolve powder completely and top up to 680 millilitres (24 fluid ounces).

- 3 tablespoons of lemon yellow in a tablespoon of hot water. Stir to dissolve powder completely and top up to 680 millilitres (24 fluid ounces).

If the powder won't dissolve, add a drop of washing-up liquid. Variation in the hardness of your water can also give different results. This solution will keep for a few days in sealed jars, as there is no soda in it. Adding urea will help to dissolve the dye more effectively and improve setting.

4. Here are the combinations of liquid-dye quantities for making a graded series of intermediate colours (a 'colour run') between two primary colours (say, red and blue).

COLOUR A (RED)	COLOUR B (BLUE)
Stage 1: 4 tablespoons	(none)
Stage 2: 3 tablespoons + 2½ teaspoons	½ teaspoon
Stage 3: 3 tablespoons + 1 teaspoon	2 teaspoons
Stage 4: 2 tablespoons	2 tablespoons
Stage 5: 2 teaspoons	3 tablespoons + 1 teaspoon
Stage 6: ½ teaspoon	3 tablespoons + 2½ teaspoons
Stage 7: (none)	4 tablespoons

On a strip of white card, or on a page of your sketchbook, mark each colour step by dipping your gloved finger in the bag of liquid dye and marking it on the paper. This will give a good representation of the strength of colour your fabric will turn out to be. It will also be helpful later on if you want to reproduce a particular shade again.

5. Take the required quantity from colour A (red) for stage 1, put it in a medium-sized sandwich bag (taking a drop to put on a piece of white card, for the record), then add a piece of fabric and squeeze the colour into it.

6. Then move onto colour stage 2, first pouring colour A (red) into the bag, then adding the required quantity of colour B (blue). Mix well, mark the colour on your card, add the fabric and squeeze the dye into it.

7. Repeat for all the remaining colour stages. When you have completed all seven stages, move on to combining blue and yellow (you can start with stage 2 this time, as you already have a pure blue bag), and then onto yellow and red.

8. Now add a second piece of fabric in each bag and gently squeeze the remaining dye into this piece. As most of the strength of the dye has already gone into the first piece of fabric, your second piece will have a lighter shade of the colour.

9. Put 3–4 tablespoons of one colour of leftover dye in a jam jar, then press one of the long strips of fabric completely into the jar and pour 3 or 4 tablespoons of another colour onto the top. Squeeze well, so that the colours run into each other, and leave to cure. The result will be a beautifully marbled piece of fabric.

10. Place the other long strip of fabric in a cat-litter tray and, using the colours of your landscape exercises, paint the fabric in a similar colour run with the dye. Be generous, and blend the shades into each other. Leave it in a warm place to cure for at least 2–3 hours, preferably overnight (turquoise, or any mix with turquoise in it, needs 24 hours to cure).

11. Rinse all the dyed fabrics under cold running water until they run clear, or put them in the washing machine on the rinse cycle and wash with bleach-free detergent at 40°C (104°F).

12. If there is any dye left over in the jars, use it to colour the pages in your sketchbook – Procion dye gives a very intense colour on paper. To add interest try sprinkling salt granules (fine or coarse) onto the wet painted pages. Similar effects can also be achieved on fabric.

Right: Recipe for success: pour a few tablespoons of magenta dye into a pot, add a long strip of fabric, add another few tablespoons of blue, squeeze well and leave to stew for a while – the result is a delicious piece of fabric.

Texture and Stitchery

There is no doubt that hand-dyeing your own fabrics adds instant texture to your work. The combination of hand-dyed fabric and quilting are key elements that change the surface of the cloth. It makes plain commercial fabrics appear positively flat in colour. If you are not keen to do it yourself, these days there are many batik or hand-dyed cottons available in the shops, at shows or exhibitions. Plain 100 per cent cotton calico is a good and very economical starting point for experimenting with Procion dyes, but any fabric with a high cotton content, silk, linen or viscose will take Procion dye beautifully.

Silk or viscose velvet produces a magnificent rich texture that is also very tactile and, used sparingly, will give your landscape quilt a real focal point. Use it in moderation because it is so difficult to sew in neat straight lines – the soft pile makes it slide all over the place. Bonding it with Bondaweb or Wonder Under is probably the best way to add it to your work.

Linen has an appeal all of its own, it takes colour in rich, subtle tones, and vintage linen in particular can be extremely textural.

Dupion silk will dye in gorgeous rich colours, and the rougher the texture, the better for adding an almost sculptural detail to your work.

Right: **Italian Felt Landscape**. *Three layers of Jacob sheep and merino wool are stacked on top of one another, each layer at an angle. The final layer consists of different colours which make up the landscape. A layer of net held it all together while I added hot water, soap and lots of friction. The finished felt piece formed a sumptuous base for a few focal points and lots of stitching. 33 x 33cm (13 x 13in).*

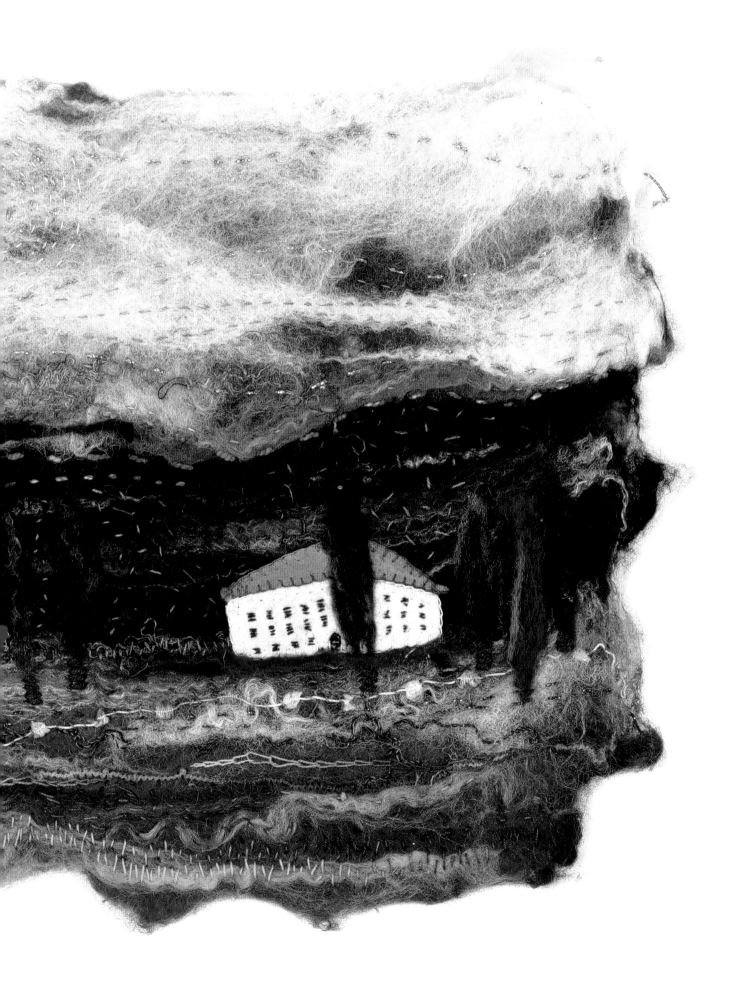

Recycling

Recycling fabrics is yet another wonderful and environmentally friendly way of using all kinds of textured fabrics. Knitted jumpers picked up in charity shops, jumble sales or the bottom of your wardrobe can be used very effectively, but be careful they are not too thick, because this can make them difficult to work with later on in the process.

Use fabrics that are close to hand, and before you donate your old clothes to the charity shop, go through them with a different pair of eyes and look at the colour and texture. The chance is you will rediscover a favourite blouse or shirt and use it to create again. Old worn denim jeans have a beautiful soft washed-out blue colour, and the added advantage of fraying nicely. A piece of brown corduroy makes a good ploughed field, and my favourites are my husband's charcoal flannel trousers with their deep flecked colour – ideal for the darker tones in the landscapes. This process reminds us that recycling was the origin of all patchwork. Early settlers in America did not have much, and every bit of cloth was cut up to be used again; worn-out clothes and flour sacks were used to make the warm blankets we now know as quilts. Cloth and clothing were very precious commodities, and recycling was a vital activity and part of everyday life.

Buddhism, one of those subjects that intrigues me and keeps reappearing in my work, also has its characteristic form of patchwork and quilting. Buddhist monks used to have a special day on which they were given scraps of fabrics and old clothes. These would then be washed, cut and pieced, usually in strips of three, then subsequently layered up and stitched all over with beautiful patterns, with a rectangular piece worn from the shoulder over the monk's robe. Turning used rags and clothes into clothing is for Buddhists a sign of seeking enlightenment.

All this has developed, using the modern techniques of quilting, into a process of construction, deconstruction and reconstruction, building up layers, strengthening by stitching through the layers, and starting all over again when a piece comes to the end of its life. Using these same principles you can build up an enormous stash of varied fabrics. Never throw anything away! Whether others in your household will appreciate your hoarding is another matter, but it is necessary if you are to make a kaleidoscopic mosaic landscape in which all the elements have their own memories for you from their previous lives as clothing, curtains and sheets.

For smaller pieces of work I also like to dye the cotton wadding, which adds more texture in the borders and contrast in the colour.

The 80 per cent cotton/20 per cent polyester Hobbs Heirloom wadding takes dye very well. As with the calico, I first soak it in a solution of soda ash in warm water (24ml in 4.5l/one cup in a gallon) for at least an hour. Even the fusible version of this wadding will still stick after it has been soaked, dyed and rinsed. Graduating and blending the colours in a large cat-litter tray is relatively easy with this thicker-textured fabric.

When using this dyed wadding in between your finished top and backing fabric you will have to give some thought to the edges of your quilt-top, because they will be 'raw'. The edges need to be frayed, so try to rip them so they are straight and frayed as part of the overall design. The same goes for the fabric on the back. Remember, you will lose about 6mm (1/4in) by stitching and quilting it.

Right: **Indian Patchwork**. *In India old saris, with their rich, beaded embroideries, are cut up and stitched together again to make ornamental textile pieces like this sumptuous cushion cover.*

Left A piece of dyed wadding and ripped strips makes a quick landscape.

Right: **Scotland 2**. *Judith Hill used ripped strips of dyed fabrics, added texture by free-machine quilting, and recycled an old coat hanger. 25 x 28cm (10 x 11in).*

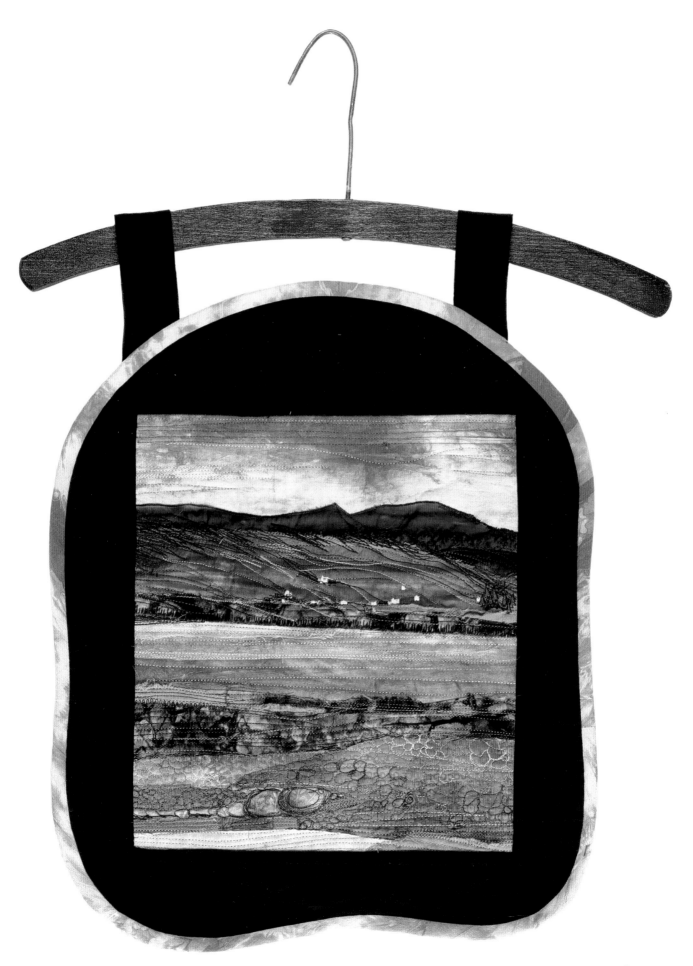

Stitchery

An integral part of each quilt is the stitching, originally a necessity to keep the three layers together but nowadays a decorative enhancement that brings a quilt to life. Stitching adds shadows and shapes, and reflects the light in different ways. The difference between a piece before and after stitching can be quite amazing.

If you are an embroiderer, the landscape patchwork will be a brilliant backcloth on which to unleash your repertoire of stitches. As a quilter you will find that experimenting with techniques other than the traditional running stitch can be an intriguing and challenging creative journey.

The colour of your thread is important too. Stitching with a thread that matches the backdrop closely in colour will create subtle movement and texture, while working with a contrasting thread will add a further dynamic to the design, giving it a more obvious rhythm and additional patterning.

There are some fabulous variegated and metallic threads on the market for both machine and hand-stitching, which when chosen to co-ordinate with your design will truly enhance it. I often dye hanks of thread at the same time as I am dyeing fabric, as a way of ensuring their colours are perfectly matched – a time-saving idea.

Try to use a combination of both machine- and hand-quilting; the irregularity of hand-stitching will give your work an organic quality, particularly when hand-dyed thread has been used. It is important to keep hand- and machine-stitching well balanced, make them work together and complement each other in your piece.

Sometimes I take work with me when travelling, and it is amazing how much can be achieved while waiting for a flight to depart; if I come home and have stitched three-quarters of the piece by hand it seems a shame to take the machine to it at all, and I usually finish it off by hand. At other times – when the texture you want can only be achieved on a machine, or the work has to be finished quickly, or the fabrics do not lend themselves to hand-quilting – machine-quilting is the obvious answer. Free-motion quilting with the sewing machine is just as imaginative as hand-quilting, and really should be thought of as hand-quilting with an electric needle.

However, I like to think that quilting some areas by hand adds a personal touch – as well as showing that you know how! A few big stitches with a thick space-dyed thread, some random seeding, and perhaps a few beads or a couched thread will give your quilt that all-important hand-crafted look.

Soft hand-quilting in a simple running stitch creates fluid lines that can then be shadowed by machine-quilting lines, while neat, straight lines will give a more angular appearance.

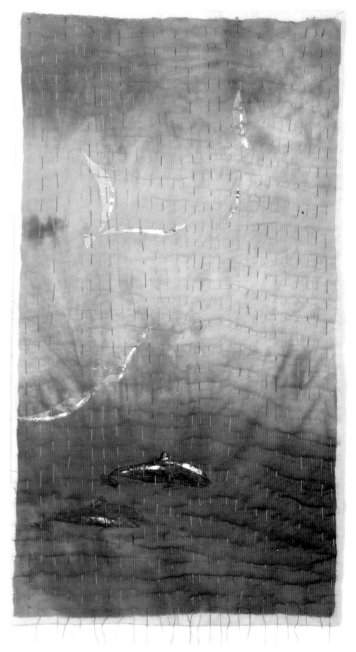

Above: **Sea and Sky**. *Dolphins and seagulls printed on dyed turquoise calico, quilted with simple big stitches in thread that was dyed at the same time as the background fabric, giving a feeling of rippling seas and shimmering skies. 26 x 60cm (10 x 23½in).*

Stitched lines can be continued into the borders for maximum impact, and also help to pull the borders into the whole work.

As with drawing and painting lines, different strokes can be interpreted by different stitches. This is where quilting shades into embroidery and gives you an excuse for another recycling trip – this time into the second-hand bookshop or the charity shop. Browsing through the many embroidery books to be found there, you are bound to find one with an illustrated stitch dictionary. Constance Howard (1910–2000) wrote various useful books of stitches (eg *Constance Howard's Book of Stitches*, published by Batsford). Such a book will provide you with plenty of inspiration when you are stuck for a stitch to fill a particular field; a few French knots scattered about, or some arrow or fly stitches, can 'sow' a field with grass.

When quilting a landscape I like to quilt each field as I go along. In some areas it is quite obvious what I should stitch into them. Others I leave until the inspiration hits me, usually when I'm working on another part. It is similar to the pioneer women of North America telling their story in a quilt. Today we are doing the same but translating our surroundings with the help of stitch.

Below: **Seagulls I**. *Painted muslin on a calico backing with torn strips of iron-on Vilene (Pellon). 42 x 33cm (16½ x 13in).*

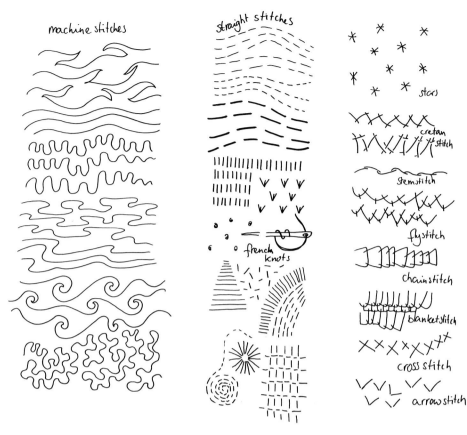

Above: A selection of embroidery stitches.

One stitch can be used in a variety of ways to create fascinating textures. The simple straight stitch is very versatile and can be used in horizontal lines, starting with larger bold ones in the foreground but getting smaller and tighter towards the horizon. To mark a path, begin with wide horizontal lines at the bottom and graduate the stitches so they become narrower as the path disappears into the distance. Straight stitches can be seeded singly, or doubled or trebled for a different effect. A thicker or thinner thread can be used to change the texture slightly, or create a different tone. Again, try bigger, looser and closer together. Lines of running stitches, forming a grid of either square or diamond shapes, are good for filling in larger spaces.

Using just one or two stitches in your work will make the piece seems less complicated, it will give it balance and make it easier on the eye, and most importantly helps to pull it all together. Simple is often best.

The spaces in between are important too – a bit like using dull colours to make bright ones shine more. Machine-stitched stones are a fine example to fill a space: the big stones stand out more if you surround them with little pebbles.

The sky is the place for long, soft, flowing lines, but with a feature made out of the sun. My favourite way to mark the horizon is a strip of tight little vertical stitches.

Some other suggestions: a green field filled with grass; a brown field with ploughed lines; a yellow field with neat lines of corn; bigger shapes can be seeded; sea can be machined with waved lines.

Try to balance the textures of the different fields in your landscape and make them harmonize with each other.

Above: **Antigua.** *Warm beaches, turquoise seas and clear skies stacked up in flowing strips. 23 x 130cm (9 x 51in).*

Pattern

Deciding which stitch pattern to use to decorate your landscape is a very important factor in the construction and finishing of your quilt. If, like most contemporary artists, you are aiming for a fairly abstract look to your landscape – in textile terms, consisting of geometric shapes or lines – it is a good idea to stick to an informal and freestyle stitch pattern.

A black-and-white photocopy of your quilt is a good place to start doodling and drawing lines freehand to see which stitches work well – and which don't.

Right: **Kimono**. *The splendid colours and patterns of the paintings by Cornish artist Gillian Ayres were the inspiration for this triptych in the shape of a kimono.*

Many patterns can be found in nature, and probably in the photograph you used as inspiration, such as those made by shells, pebbles, grasses, bubbles, water or clouds. These can be used to fill in areas with informal texture and background pattern. Remember to keep adding these ideas to the pages of your sketchbook.

Below: **Seaside sketchbook**. *The quilted cover of this sketchbook was inspired by the beach near our house in France.*

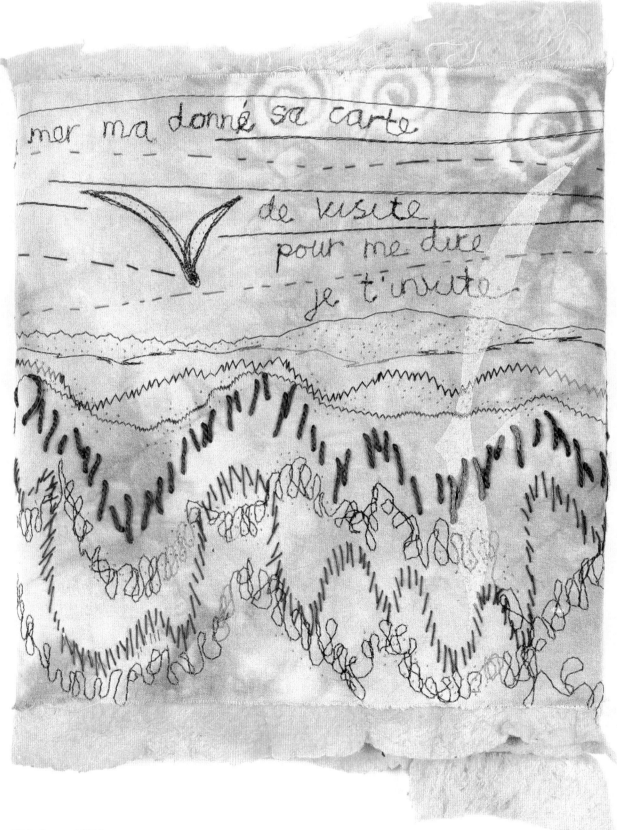

Right: Inside pages from the sketchbook shown opposite.

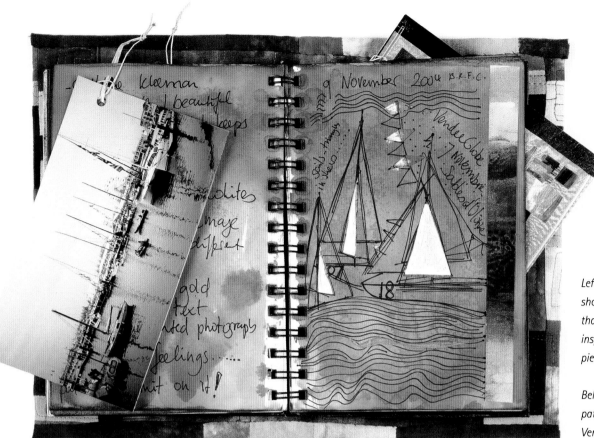

Left: A sketchbook
showing pages
that were the
inspiration for the
piece opposite.

Below: Stitch
pattern for
Vendée Globe.

Where does one find ideas for stitches? Exhibitions are a good source of inspiration for all design matters, but sometimes it helps to concentrate on stitches in particular. For more than a year I carried a small sketchbook and pen in my bag purely to record interesting free-machine and hand-quilting patterns. This is an excellent way of building up an extensive library of stitches on which you can fall back when stuck for ideas.

If a pattern works in the way you want it to, more often than not it will provoke a response from admirers as they recognize your rendition of grass or stones.

Random doodling with pen or pencil can produce usable stitch lines too. You don't really need to be able to draw to do this. Have your sketchbook handy and draw any pattern, motif or shape that attracts your attention. You never know when an idea might come to you, and they are handy to refer back to when inspiration is needed. The sails in the window-hanging shown on the opposite page came about that way.

By looking at the shapes in my design I started to draw and, echoing the lines of the shapes, eventually came up with this pattern. Stitched in a variegated thread that co-ordinates with the majority of the fabric colours used, I machined all over and finished with some gold or silver highlights. I changed the shape, size and density too – this helps to keep it interesting and balanced.

Opposite page: **Vendée Globe**. Shapes of cotton and sheer fabric caught between too layers of sheer polyester and stitched by machine using variegated and silver threads. This piece is double-sided. 21 x 29cm (8¼ x 11½cm).

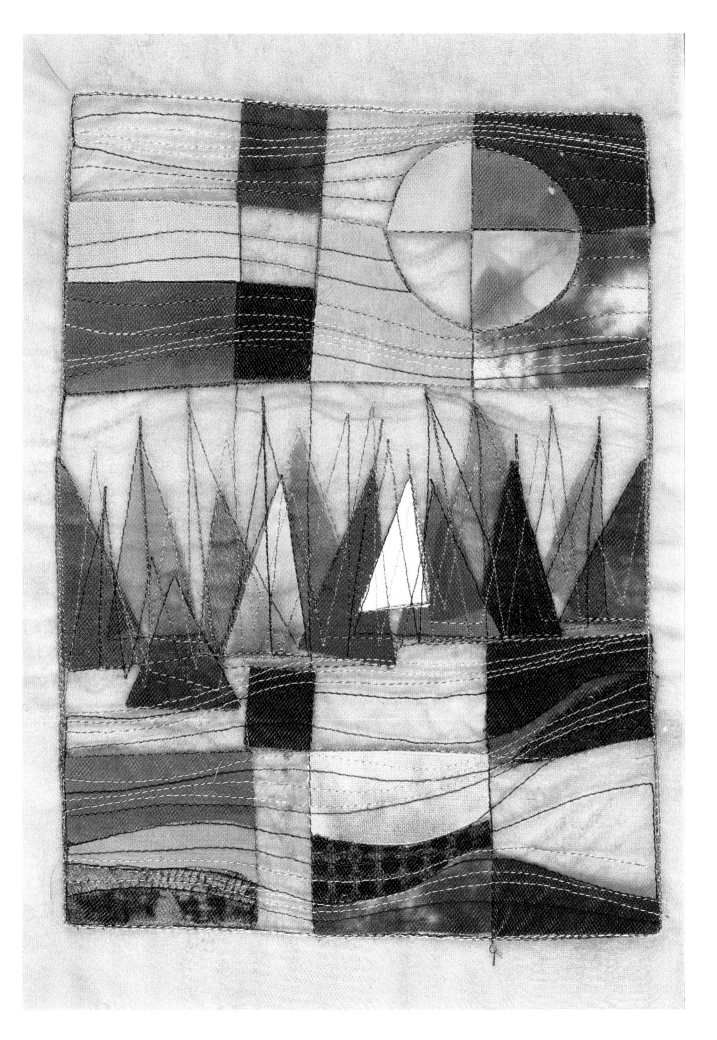

As the lines were very straight and angular, I machined these patterns with an ordinary foot, with the feed-dogs up and the needle in the down position, and just kept turning. I tried to keep the line going continuously as much as possible to avoid too many loose ends to finish off afterwards. Reducing the number of loose ends helps particularly in these sheer-on-sheer pieces.

Go back to the original photograph you used as inspiration, or have a look through your other photographs for the landscape projects, and this time look for different aspects of the image as a source of ideas on pattern and texture.

If you're really stuck, another landscape-related source of pattern is a topographic map (in Britain, an Ordnance Survey map) of the place where your source photo was taken. Trace the roads and contour lines of the area to build up a pattern that can be repeated in blocks, enlarged or reduced. This gives you instant stitching lines.

The patterns of the borders must be thought of as an integral part of the piece. You can extend your stitching from the picture area into the borders, which will also bring colour into a dark surround. Appliqué a few trees (overlapping the seams will soften the edges), or perhaps treat the border as a frame and choose an all-over pattern. This might be simple, straight machine-stitched lines or you could go for garlands of leaves or flowers.

Layers

Another way of changing the texture is by adding another layer on top of the main surface. Houses, a church, a whole village, trees or boats can all be fused on with Bondaweb (Wonder Under). They can be pieced, of course, but it is much quicker to stick them on. In one of my earlier landscapes I took the trouble to piece a row of houses with angled roofs one by one, but it took a very long time, and when your work is quilted and embroidered you cannot see the difference.

I start by sorting some suitable coloured fabrics and iron-on strips of Bondaweb. I can then cut them up into the required shapes for houses, or thin strips for tree trunks. It is easier if you leave a tiny bit of fabric showing when cutting out the different shapes, so you can get your fingernail under the paper to peel it off. Once you have arranged your shapes on the landscape and you are happy with their positioning, peel off the backing paper, cover the piece with baking parchment and iron the shapes into place.

Right: **Beach Huts.** *Different fabrics are machine-pieced in gentle curves, giving a good example of the combination of hand and machine stitches. The huts were appliquéd on afterwards. 100 x 35cm (40 x 14in).*

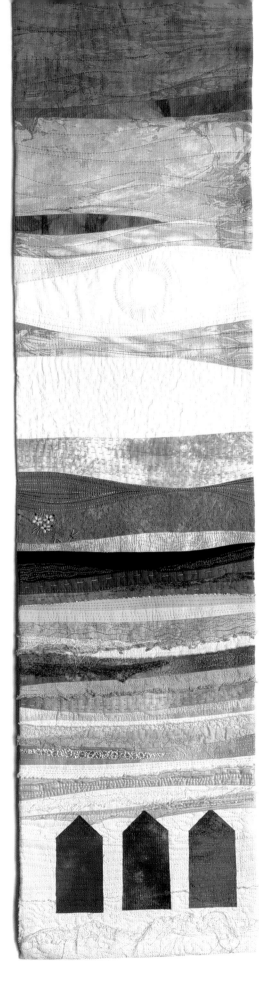

You can also think about the layers within the picture you are presenting. Sometimes all that is missing in a purely horizontal landscape is one interesting tree or building as a vertical division.

Seascapes need very little vertical interest – maybe a sail, a beach hut or just the outline of a bird in the sky – compared with landscapes, where some vertical lines are required to liven it up in the shape of a house, a village or a group of trees.

Trees are an essential part of most landscapes, but ask ten people to draw their version of a tree and you will get ten different trees. I like to add trees to my quilted landscape, but in my abstract style they are very basic – straight trunks fused on with Bondaweb (Wonder Under) and, for the foliage, many rectangles cut or torn out of a selection of sheer fabrics, stitched on in layers by hand with simple stitches.

In *Summertime* (below), the tops of the trees have been stitched on at the end when the whole piece is finished. They are done last because the raw edges fray during handling, and may even disappear if put on too soon. Another fabric useful for representing treetops is the type of thin fibrous sheet used for tumble-dryer fabric conditioners; these have an interesting texture, and can be painted with inks or dyes.

Adding layers of sheer here and there is another way of changing the texture. Tear or cut small rectangles of sheer fabrics in tonal shades (lighter or darker shades of a given colour) and after pinning, stitch them on overlapping each other with a simple running stitch in a matching thread.

Right: **Summertime**. *This landscape shows how the houses and trees are bonded or stitched on after construction. 80 x 75cm (31½ x 29½in).*

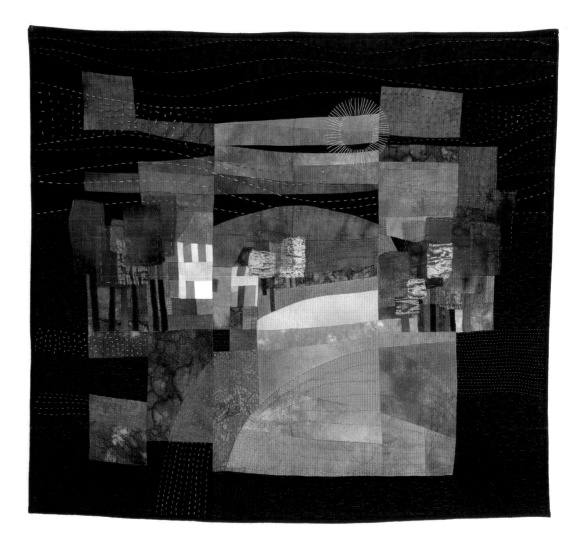

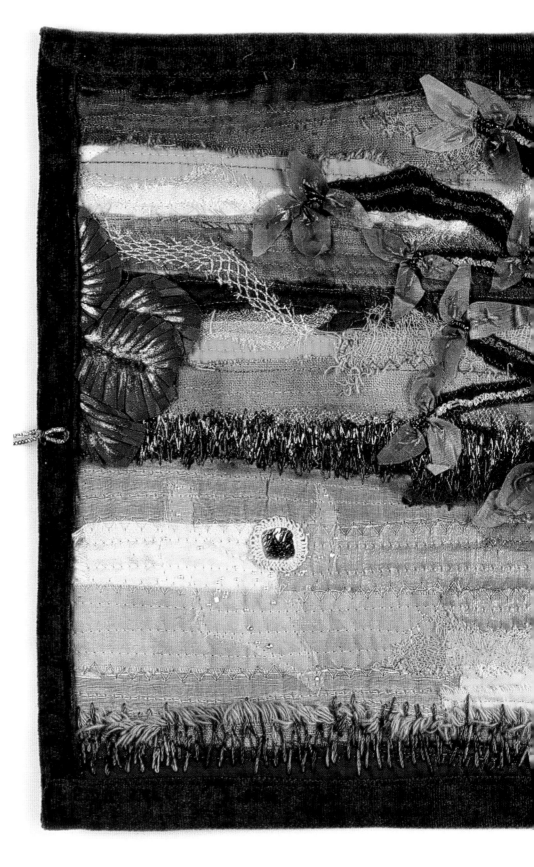

Right: **Tree book cover** *(Janet Carpenter). Many ripped layers placed on a base of fusible wadding and bonded by ironing. Machine-quilted with a wide variety of stitches. The trees, leaves and shisha mirror details were appliquéd afterwards and finished off with some hand-quilting and couched threads. 45 x 27cm (17¾ x 10½in).*

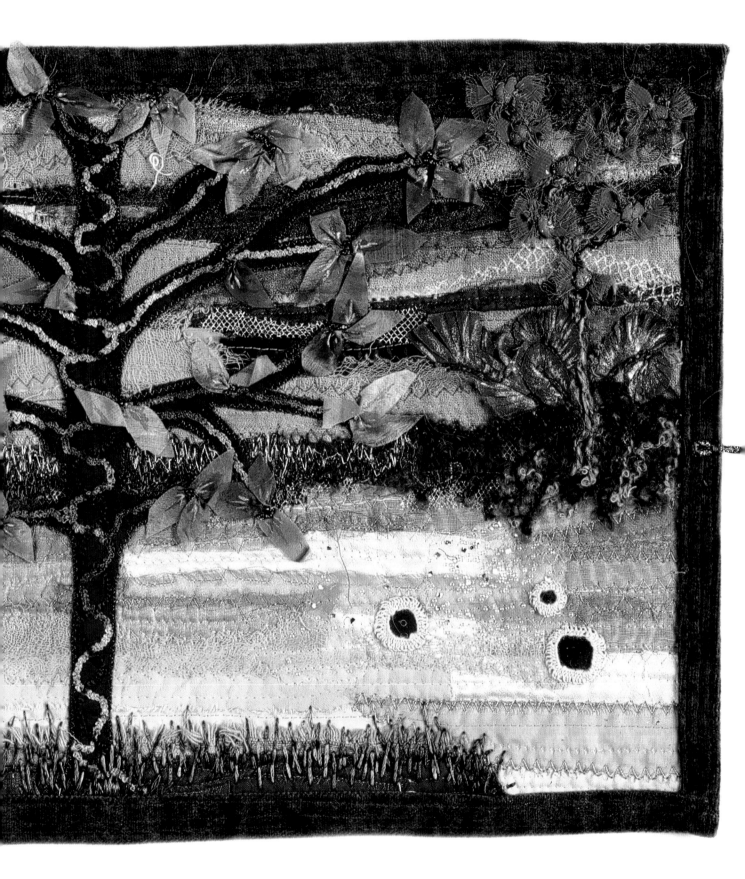

Edges and Texture

When piecing your landscape, adding a few raw edges in between the stitched ones can also be used to give texture. Linen frays beautifully and gives a real 'field' feeling to stretches of yellow or green. You can tear, fray, rip, cut or even burn edges of different fabrics to create an irregular edge.

When using more than one layer, the top one can be slashed close to the stitching line and brushed to reveal the underlying fabric. This adds a stringy effect when cut straight across the fibres, or a softer, gentle fray when slashed across the bias.

Below: This little pegbag is a good example of the layering of several fabrics. I stitched parallel lines in different patterns and then slashed the fabric between the lines. Beads and some gold machine embroidery were added afterwards.

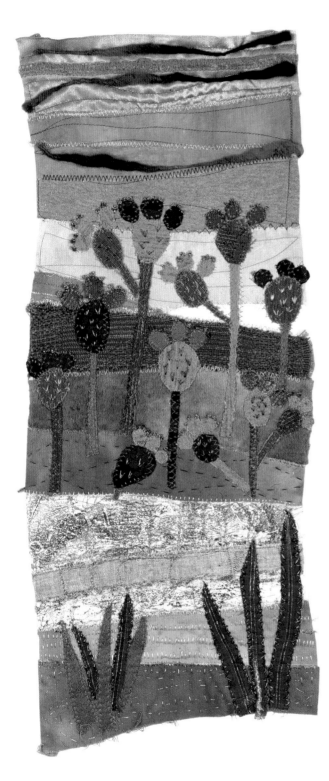

Above: **Cactus** *(Heather Stratton). Strips of fabric were ironed onto fusible wadding, then cacti shapes were stuck on using Bondaweb (Wonder Under). The piece was then quilted by machine and hand. 23 x 53cm (9 x 21in).*

Right: **Salt**. *This piece was made for a competition organized by the Salt Museum in Delden, Holland. My starting point was a lino-cut of a square salt crystal. 90 x 28cm (35½ x 11in).*

Left: **Winter Wonderland**. *The appliquéd trees and appropriate stitching make this red-brick village come to life. 35 x 35cm (13¾ x 13¾in).*

Bits of scrim, net, organza, muslin, hessian or velvet are perfect for breaking up larger areas of plain colour, or covering up a seam that is a bit too obvious. And the new Angelina fibres, available in a dazzling rainbow of colours, are excellent for adding soft, transparent layers of texture. All these different fabrics and fibres can be applied with Bondaweb or with an ordinary glue stick before being stitched on. Textured and slightly thicker variegated threads or knitting wools can be applied too. They can be couched on by hand, threaded with a few beads or zigzagged on by machine. Again, use them to disguise seams and blend the landscape together. When stitching, I will do a few stitches on the spot to anchor the ends, which can then be cut off as short as possible.

Free-Machine Quilting

The main secret of free-machine quilting is: Practice! Practice! Practice! Make sure your machine is clean and in good working order, and put in a new needle. Read and follow the instruction manual: free-machine embroidery might be mentioned under the term 'darning', and the foot necessary for this kind of work is the darning foot, either a rounded transparent plastic foot or a metal one with a wide front opening. This enables you to see where you're going and what you've done.

You can stretch your work in a quilting frame or embroidery frame with the flat side facing downwards, but personally I find these too restricting. Because you are working with several layers, some of which can be quite stiff, you will not need the special machine-embroidery hoop.

If your thread keeps breaking or snagging, more often than not it is because the needle is blunt or slightly bent. Try to use a good-quality needle such as those made by Schmetz; a size 70–80 will be appropriate for this kind of work. Make sure you start with a full bobbin in a colour similar to your top thread. Your main thread should co-ordinate with your fabric, or alternatively use a clear thread, such as the type made by YLI.

Use your darning or special free-machine foot and lower the feed dogs. Your manual will tell how to do this; usually there is a switch you have to turn or lever to raise. Use a straight stitch, with the length set to zero. You might find it useful to wear rubber gloves, or canvas gloves with rubber dots on the fingers to get a better grip on the fabric. Reduce the top tension by 1 unit or more if necessary – have a sample square handy to practise on, with the same fabric and wadding you are using in your piece. It will also help if you make yourself familiar with the pattern you are going to stitch by first tracing or doodling it with pen and paper.

Bring the bobbin thread to the top by taking one stitch and pulling the top thread – the bobbin thread will come up. This will help you avoid a tangle at the back. Move your quilt backwards, forwards and sideways to control the length and direction of the stitch.

To stop your neck and back getting too tense, put a couple of rubber doorstops under the back of your machine to tilt it slightly towards you. You will immediately feel your posture ease. Keep your sewing sessions short – about 20 minutes or so at a time – and don't forget to breathe!

As an exercise, take a 300mm (12in) square of calico – plain or dyed – and fill in a landscape using different stitches. Base it on a photograph showing a landscape with good texture. Make a line drawing from it on to the calico, and then start stitching. This is a good opportunity to test out the programmed embroidery stitches of your machine in a free mode.

Different surface textures can also be created by manipulating the fabrics. Strips can be ripped and woven together again. Before using a piece of fabric it can be pleated randomly to create an interesting surface. In *Here Comes the Sun* (see p55) I randomly stitched narrow curved tucks into the fabric and then quilted around them.

Left: **On the Water (detail).** *Close-up of machine stitching. See full picture on page 97.*

Project: Making a Book Cover

The idea of using strips of fabric to make landscape cards (see page 40) can be used to make a cover for a sketchbook or a simple wall-hanging.

Materials and Equipment

To cover an A5 (148 x 210mm/5¾ x 8¼in) sketchbook you will need the following:

- Piece of backing fabric (any colour), 330 x 560mm (13 x 22in)
- Piece of medium-weight wadding – fusible, covered in Bondaweb (Wonder Under) or sprayed with a textile glue, 280 x 510mm (11 x 20in)
- Fabrics in the colours of your landscape
- Threads to match

1. Cut or tear strips of different widths, from 13mm (½in) to about 75mm (3in). Because you are working with quite a wide piece, you can use two or three pieces to cover the whole width.

2. Place the wadding in the middle of your backing fabric – remember to allow 13mm (½in) for the seams. Before you actually bond your strips to the wadding, play with them on your cutting mat to get the composition right.

3. Starting from the bottom, place a couple of the wider, darker strips on the wadding. Then have a section with brighter, narrower strips, layering some with raw edges or net.

4. Think about where your horizon is going to be, and if it will be a straight line, or whether there are hills in the background. The sky just above the horizon should be quite light, working up to darker sky at the top.

5. When you are happy with your composition, bond the pieces onto the wadding.

6. You can now add interest by appliquéing pieces of sheer, muslin or dyed fabric to make the shapes of trees, houses, sails and so on. Your work is now ready to machine- and/or hand-quilt.

7. Use a Hera marker or the blunt end of a thick wool needle to mark out your stitching lines. Remember to leave space to add some hand-stitching later.

8. When starting off, choose threads that blend into your design rather than contrast with it; this will help to hide any mistakes. If you are not confident with your free-machine stitching, stick to straight or flowing lines, which work just as well – especially in the fields and the sky. Practise free-machine stitches by doodling with a pen or pencil in your sketchbook.

9. To finish off, stitch a binding on the short edges first. Measure where to fold it around your sketchbook, pin to secure the top and bottom of both sides, and check again! Now bind the top and bottom with the sides folded in, leaving 13mm (½in) on each corner to fold in. Then machine-stitch the right sides together, fold towards the inside, and pin. Or, to get a neater finish, stitch the binding by hand.

Right: Ripped strips of fabric bonded onto wadding formed the basis of this book cover. The trees and house were appliquéd on and the cover was finished with plenty of free-machine quilting.

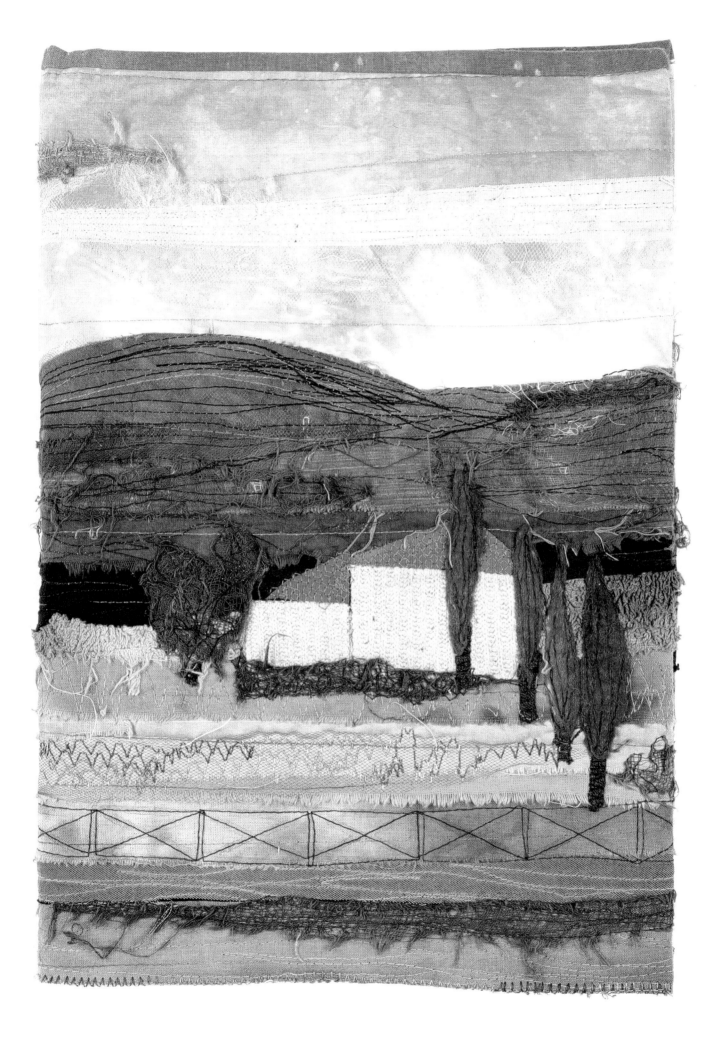

Layers and Design

Three-layered Quilts

Part of the definition of a traditional quilt is that it consists of three layers:

- A top layer, which can be whole cloth (that is, a single piece of fabric), whether natural or dyed, or a pieced fabric (that is, made up of several separate pieces).
- A layer of wadding, which comes in a huge variety of types – polyester in various thicknesses, 100 per cent cotton (or a combination of polyester and cotton called Hobbs Heirloom 80/20), wool, silk, and even fusible wadding.
- A backing fabric, plain or patched.

For the contemporary quilter this definition can be approached in many different ways, but for a quilt to qualify to enter most quilt competitions nowadays, it has to be constructed of at least two layers.

Right: **On the Water**. *This double-sided sheer hanging is made up of a patchwork of hand-dyed cottons and sheers, bonded onto a sheer polyester backing and covered with a final layer of tulle. 66 x 120cm (26 x 47in).*

Quilting is a traditional craft but is also considered as an art form. If you would like to create a piece of art rather than just a quilt, you can interpret these layers any way you like – the sky's the limit!

There are so many different types of fabric around today that experimenting with them is crucial to finding out what the possibilities are. A trip around the market stalls or to a discount fabric store will present you with many new ideas. Layers of sheer, organza, net, tulle and muslin in a huge assortment of colours can be piled on top of each other, decorated with imaginative stitching and developed into stunning pieces of translucent 'window art'.

If you'd rather stick to natural fibres, a softer option can be put together by using a soft, dyed calico cotton as your base, and placing shapes of coloured cotton, gauze, muslin, silk, linen scrim or soft lace on top to build up an appliquéd and thin-layered landscape. A top layer of petticoat net or tulle, in a colour that tones in well with the background, holds it all into place, and your work is ready to be tacked and stitched with coloured threads and lots of stitching. This is a technique favoured by Linda and Laura Kemshall. They create gorgeous bags inspired by Indian dowry purses, some of which are almost 'stitched to death' but yet remain wonderfully soft to the touch.

Instead of wadding, another layer of fabric can be used. Indian pieces are often built up of layers of old saris and stitched together with threads taken from the same fabrics. Lots of tiny stitches draw out patterns, and lines are echoed all over the cloth. These quilts are beautifully light and drapable, ideal as a lightweight cover-up on hot nights.

This way of quilting is called Kantha, and I find the simple way of stitching it involves very suitable for my own landscape quilts. Also, old saris bought in charity shops can provide you with rich fabrics often embroidered and embellished with gold and beads, giving a bit of sparkle here and there. By overlapping different shades and colours of sheer fabrics you can bring out different colours. For example, by layering yellows and reds you create orange, and when you group several pieces together you end up with a wonderful cocktail of tones and shades. As you can see on the piece on the opposite page, alternating sheer areas with some solid pieces results in a well-balanced piece in which the 'empty' spaces are just as important as those that are filled in.

A landscape view is built up of layers: the ones in front that we can see clearly are bright, while in the distance the colours become duller because moisture, dust and pollution in the air create what is called 'atmospheric perspective'. Increased distance also makes shapes appear narrower, and fields show dark borders formed by the lines of trees.

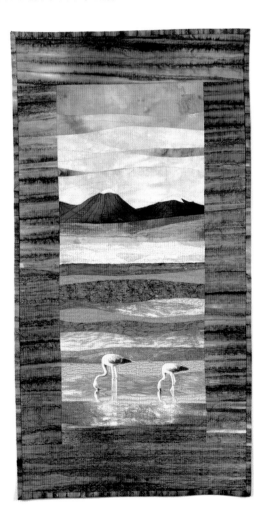

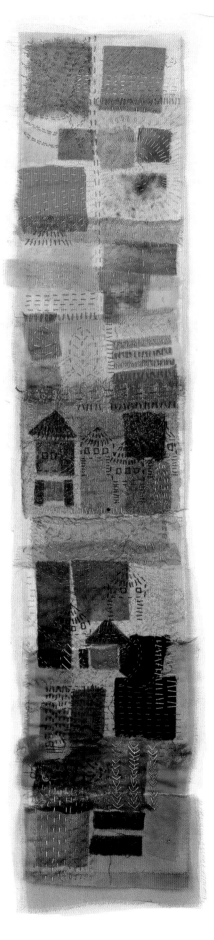

Right: **Flamingo Lake, Chile**
(Vivienne Taylor). Free-flowing curved pieces make up this wall hanging, a beautiful composition of colours and shapes. 45 x 90cm (18 x 35in).

Far right: **Thailand**. *Geometric cotton shapes were placed on a backing of pale yellow cotton, then strips of different-coloured tulles were placed over the design to change the tones. 15 x 80cm (6 x 31½in).*

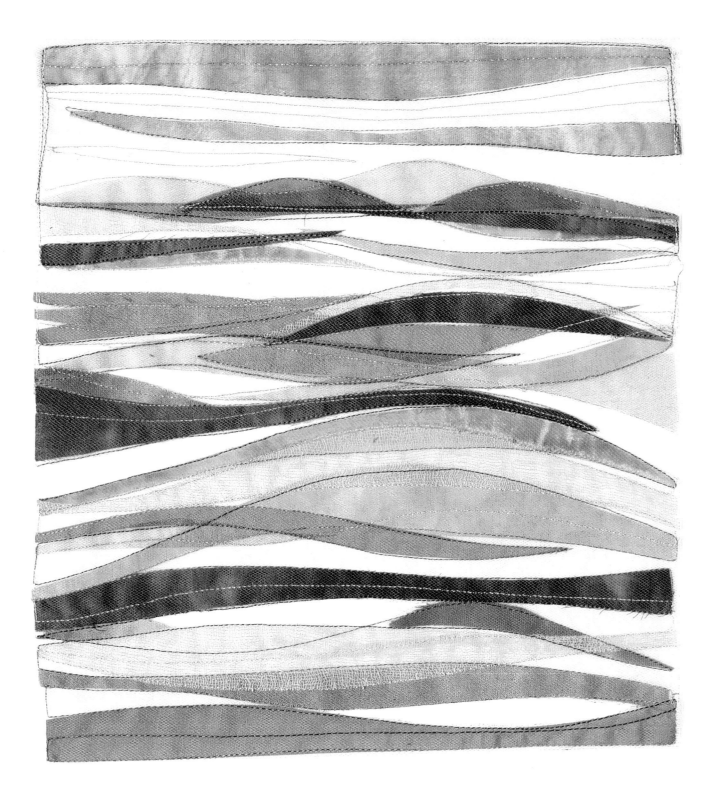

Above: **View of Malvern**. *Part of a triptych, this piece consists of layers of sheers and cottons trapped between organza and tulle. It is usually displayed in a clear acrylic clip frame. 26 x 26cm (10 x 10in).*

Composition Revisited

Returning to your landscape photograph source, we will now move onto the next stage of development and look at a wider aspect. I suggest you start with a piece of paper no bigger than an A3 sheet (297 x 420mm/11¾ x 16½in); divide the space into a grid of three vertical columns, and cross these with some horizontal lines. Remember that to make the picture interesting you need to place these lines so that they divide your space into uneven sections. For this reason, place both your horizon and the vertical line away from the centre (a). Add another horizontal and vertical line (b), making sure your spaces are not equal. In doing this it will help to think of the 'principle of threes': small/medium/large; three houses; three trees or three groups of trees. Depending on the shape and size of your next piece you can add more sections if you wish (c). Try to give the eye an opportunity to travel around the picture. It is crucial to start off with a well-proportioned design.

You can now colour in the shapes, remembering the principles you learned earlier:
• Bright colours in the middle.
• Strips narrowing towards the horizon, colours deepening.
• Sky immediately above the horizon is quite pale, becoming darker higher up.
• Frame the centre with larger, darker blocks of colour around the outside, making the bright colours glow.

I find watercolour or acrylic paints are quite handy for this stage. With acrylics the colours are bright and more opaque, and you can go over them quite easily to make them more intense or darker.

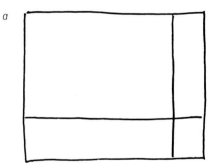
a

 This painting will be the starting point for your working design. Don't worry if your picture is hopeless; we are not trying to create fine art – just a colour guide to show you where to place your fabrics.

 For the base cut a piece of fabric slightly larger than the A3 piece of paper, or anything up to about 25mm (1in) bigger than your design.

 Now you are ready to select fabrics in the colour palette of the painting. Iron them if they are very creased, and perhaps cut them into smaller geometric shapes.

 You can either start with the bright colours in the middle and find the darker ones for the outsides later, or do the reverse and pick out the dark colours first and find the lighter contrasting colours for the central, brighter postcard section afterwards.

b

 Place appropriately cut shapes of fabric to form the mosaic-like picture, solid ones first, and then experiment with overlapping some sheers. This will create darker or lighter shades and also add texture.

 Because the shapes are not stitched or bonded at this stage, you can play around with them until you are happy with the overall look. You can use a different piece for each block, or limit your choice and bounce the same colour fabric around your design – giving it balance and pulling it together at the same time. Remember you need dull colours in your design if you are to bring out the sparkle of the bright ones. If some sheers are a bit volatile and keep blowing away, use a bit of glue stick to keep them in place.

c

 Next we place a piece of thin net or tulle over the top. Try out different net colours to see which one complements the composition colours best. Sometimes a bright purple tulle is just what you need; other colour schemes might profit from a dull silvery grey to make things shimmer.

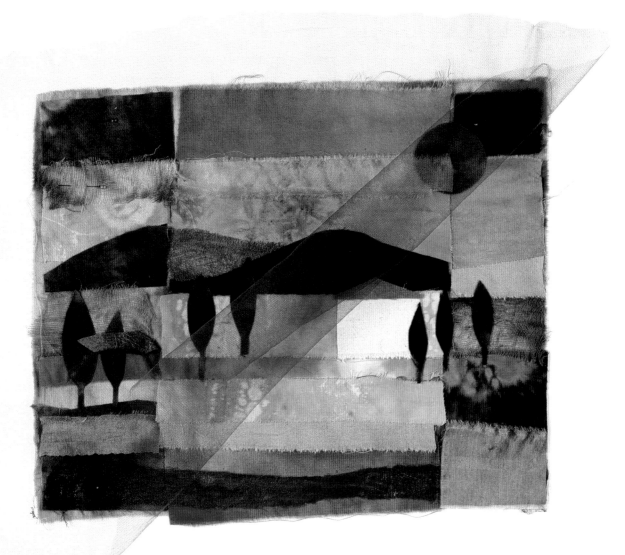

Above: Work in progress on a sheer piece. Geometric shapes were laid on a background fabric, then focal points in the shape of a house and trees are added. The tulle was placed on top – the layers are shown ready to be tacked (basted) and stitched by hand or machine.

Carefully pin and tack all the layers together, taking care that the small bits of fabric don't fall out. You are now ready to start stitching quite intensely all over – by hand, by machine or both.

Experiment with different threads and different stitches, or use one stitch and vary its length, width, repeat rate and so on. You can keep within the created grid, or you can choose to lose the boundaries and let blocks of stitches flow into neighbouring columns.

As a quilt artist I am always looking for new ways to interpret the landscape into a layered piece of textile. I like my work to evolve, but it should still be recognizable as one of my pieces – I like it to have my identity woven into it. A visit to a museum or gallery can open your eyes to a new approach. International quilt shows and exhibitions bring together a wide variety of textile artists, exhibiting their designs and often demonstrating their latest techniques. Attending these shows gives us all the chance to broaden our creative horizons. Always carry your sketchbook, and take notes and photographs to make sure you keep a record.

Journal Quilts

Apart from keeping a sketchbook, another interesting exercise is to develop a journal in textiles by doing a quick monthly piece of work inspired by that particular month. It may be the season, an event or perhaps an obsession that can set the creative ball rolling. Getting together a group of like-minded quilters and setting up a challenge to exchange photographs of the finished work by the end of the month can be a way of giving you the discipline you need.

Keeping the work small – say A4 (210 x 297mm/8¼ x 11¾in [in North America letter-size paper is similar]) or postcard size (100 x 150mm/4 x 6in) – means that it can be completed in a short time, it won't take up too much space and can easily be scanned or photographed for sharing among the group. Give your project a theme to help focus your thoughts, and give unity to the finished piece by limiting yourself to these areas:

• Subject, such as a tree, a particular geometric shape, or an event
• Technique used: pieced, quilted, appliquéd, sheer, and so on
• Media: fabric, paper or both
• Colour
• Machine- and/or hand-stitching

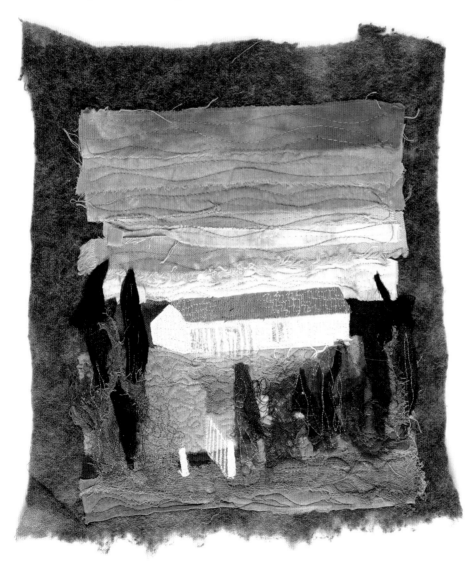

Left: This journal page was the first in a series based on a theme of 'what did I do in the summer?' That particular summer we acquired and rebuilt a bungalow in the Vendée region of France – shown in this piece, which was created in a one-day workshop session.

Right: **Tsunami journal page**. *When the south-east Asian tsunami struck in December 2004, I felt compelled to create a page as part of my journal series. I used newspaper cuttings, sheep's fleece, builders' scrim and ripped strips of sheer fabric and handmade paper. 28 x 40cm (11 x 15¾in).*

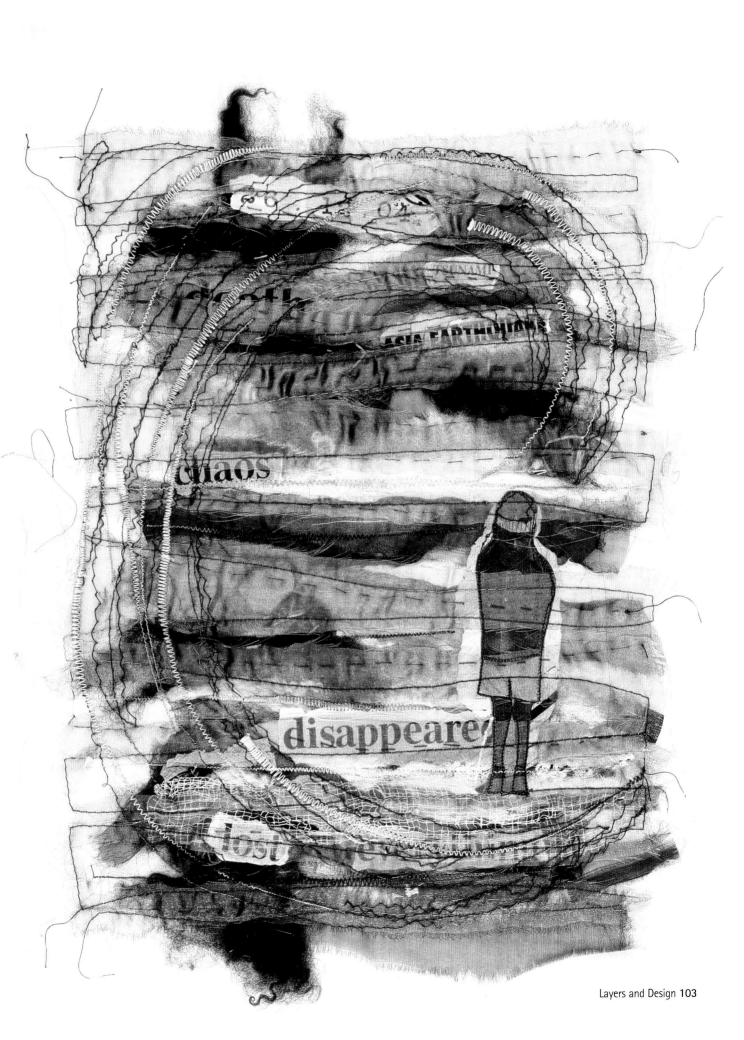

Project: Making a Landscape With Sheers

There are various ways of using sheer and textural fabrics. Using sheers and nets together will produce a transparent hanging that would look fantastic in a window or glass door.

Materials and Equipment
- Photo or card to use as source material
- A4 piece of paper (210 x 297mm/8½ x 11¾in)
- Pencil, pen and watercolours
- 400 x 500mm (15¾ x 19¾in) neutral-coloured sheer fabric, polyester or silk organza
- 1 piece of 400 x 500mm (15¾ x 19¾in) coloured net or tulle
- 500mm (19¾in) Bondaweb (Wonder Under)
- Selection of coloured fabrics and other sheers
- Selection of coloured machine-embroidery thread (variegated is good)

In this example I used a polyester sheer as the base fabric, and I bonded hand-dyed cotton and muslin on the sheer with Bondaweb (Wonder Under). Polyester sheer curtain fabric works well – as long as you remember to keep the iron cool. It is cheap and easily available, while silk organza is more expensive and gives a slightly more opaque effect.

I have made double-sided versions in this way, with bright colours one side and icy blues on the other, but I suggest you start with a small A4-size piece and make a single-sided version first, as working with Bondaweb and mirror images is quite complicated. Doing one side gives you the chance to become familiar with the whole process of inverting your drawn design onto the Bondaweb, cutting it out, bonding it to the fabric and finally bonding it to the sheer background.

1. Use a photograph or picture as inspiration, and start with a grid pattern drawn on A4 paper. For the piece on page 106–107 I used a combination of a Christmas card and work by Paul Klee as my inspiration.

2. Work out the squares you are going to fill in and the ones you are leaving clear in a chequerboard pattern – but, as always, don't stick to this rule too rigidly. Paint your design in with colour to give you a guideline. While you are placing fabric pieces onto the sheer background – before actually ironing them into place – take a look and decide whether or not you might want to interchange some squares. Adding a coloured sheer piece here and there works very well to soften the hard edges at the margins of the coloured fabric where they are adjacent to an empty space. Some strips look good when drawn out almost across the width of your design, alternating shades from dark to light along the way. Maybe leave a section out here and there – the open spaces are as important as the coloured ones. The difficulty is in deciding which ones to leave empty!

3. Cut a piece of the sheer fabric, 50–75mm (2–3in) wider than your pattern and with 100mm (4in) spare at the top, to enable you to insert a rod for hanging. The obvious advantage of working with sheer fabric is that you can place your design underneath it and bond your shapes into place – just like painting by numbers!

Right: **View of Malvern.** *The second of my triptych showing views of Malvern in sheers (see also page 99). 26 x 26cm (10¼ x 10¼in).*

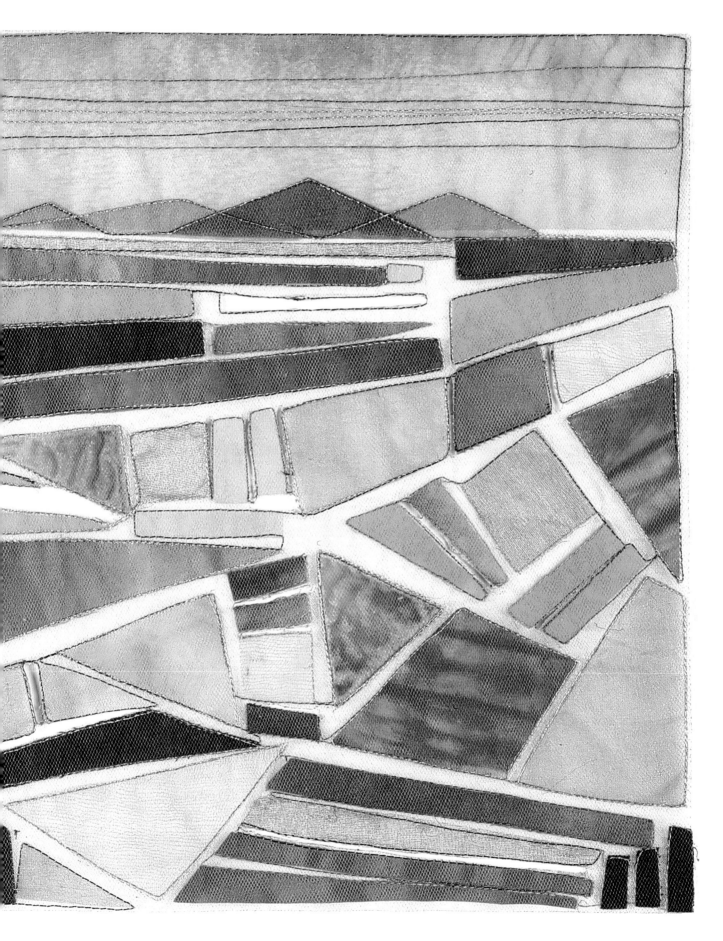

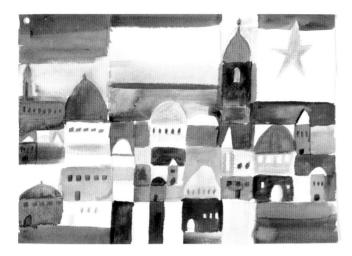

Above: The watercolour design I used for the Christmas card shown right.

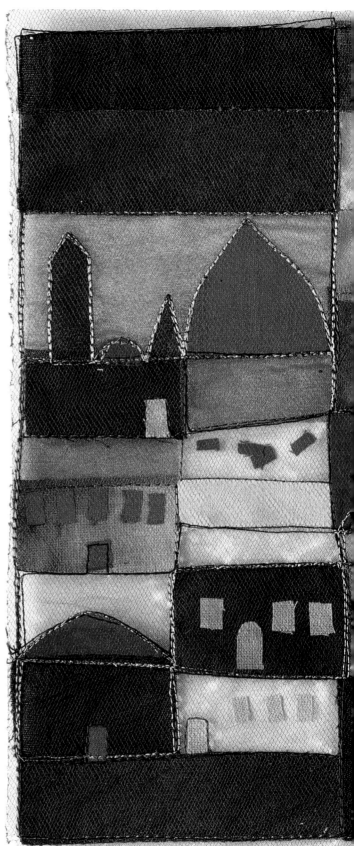

4. Occasionally I have used a piece of sheer or dyed-cotton scrim to achieve a more textured transparency. For the sails and the tree tops, shapes of varying tones can be overlaid, creating subtle differences in lightness and shade.

While you work with Bondaweb you have to remember that you need to copy each shape in a mirror image – it might be a good idea to photocopy your design as a mirror image, or trace the design through onto the back. Another easy way of filling in the spaces is by selecting the fabrics you are going to use, iron an A5-size (148 x 210mm/5¾ x 8¼in) piece of Bondaweb onto the back of each piece and cut the shapes out freehand as and when required. Have plenty of spare fabric handy for the mistakes you are going to make!

5. I like to work from the bottom upwards, filling in the design square by square. It is easy to lose the small pieces while you are cutting and bonding, so iron them on while you've got them in place. I am sure each quilter has her or his own preferred way of approaching this technique.

Remember that the polyester sheers are not very heat-tolerant, and nothing is worse than burning a hole in your work when you're almost finished. It is very important therefore to test the polyester first carefully with the iron, and always use baking parchment both underneath and on top of your work. This will keep your iron and ironing board clean. (Silk organza is a more heat-friendly alternative to polyester, but gives a more opaque result.)

*Right: **Bethlehem**. Geometric shapes bonded onto a sheer polyester background, with a top layer of tulle, outlined with variegated and gold threads, then photographed for a Christmas card. 21 x 30cm (8¼ x 12in).*

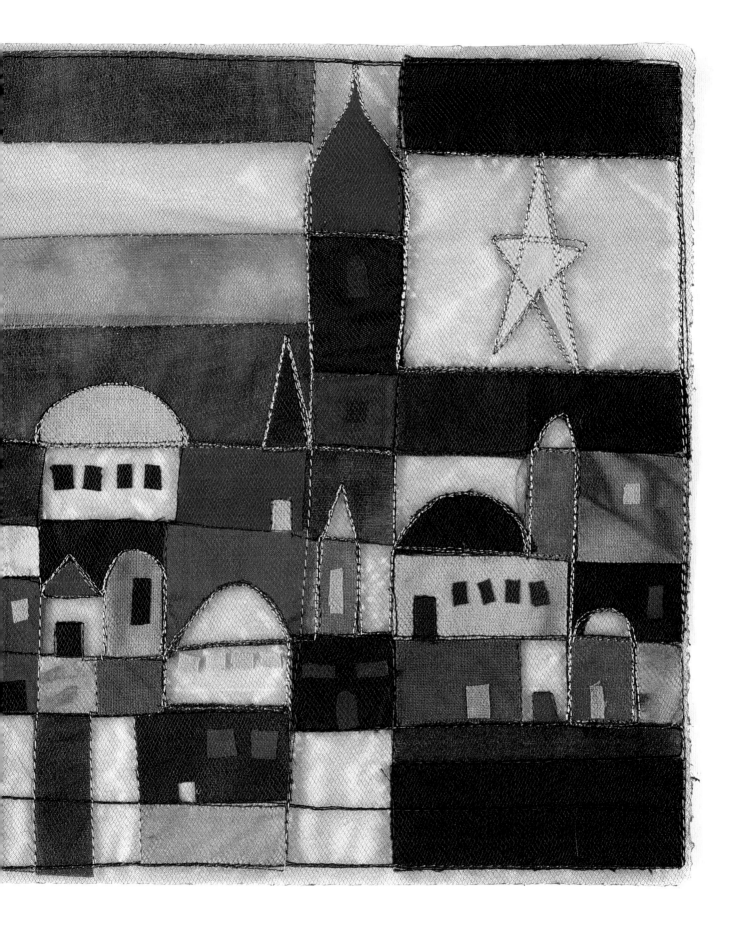

6. When all the pieces are bonded in place on one or both sides you can layer a piece of net or tulle on each side and pin the three layers together. While pinning you will notice that all the layers of fabric and Bondaweb make it very difficult to get a pin or needle through, but the 'sandwich' can be tacked (basted) using the spaces that are kept free.

7. To quilt your piece, machine-stitching is the best option. I love the variegated threads that are on the market now, and if chosen well you will not have to change the thread very often – or at all.

To decide on your stitching pattern, your best bet is to go back to your initial drawing and picture and take inspiration from your design source (see page 84). Maybe make a couple of photocopies of your piece and sketch some lines onto it. This is exactly how my own stitch pattern came about.

8. Always remember to stitch a sample piece first to get the tension and stitch length right, both through just the sheer layers and the bonded layers, and make a note of it in your sketchbook to refer to later. Keep the stitch length short on your test piece, since it is only small. This will also give you a good opportunity to familiarize yourself with the pattern you are going to use. If the lines are more or less straight I prefer to use the walking foot of my sewing machine.

9. Start by stitching the straight dividing lines of the grid, and then fill in the pattern. When you have finished with the coloured thread, you might like to add a few lines of silver or gold – but that it purely a matter of personal preference. Not everybody likes the glitter of metallics.

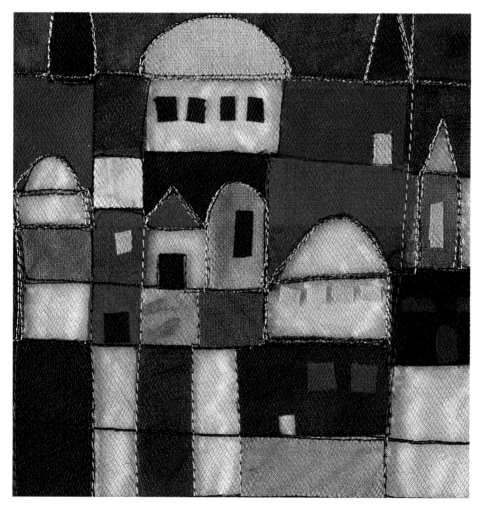

Left: **Bethlehem** *(detail).*

Finishing Off

Before finishing off the edges, you need to decide how you are going to display your work. Here are some suggestions.

The piece can be cut down to exactly A4 size (or whatever base size you are using) with a soldering iron and then placed in a clear acrylic display holder; these are available from large office stationery stores.

An alternative is to attach some small metal curtain-hanging clips, available from furnishing stores, and slide these onto a metal or wooden rod. Or you can stitch a 25 or 50mm (1 or 2in) tunnel about 25mm (1in) above the top line and insert a transparent acrylic rod, available from plastics suppliers.

10. Depending on which way you choose to hang your piece, you can now finish off those fraying edges effectively by using a fine-tipped soldering iron. Remember health and safety at home and only use in a well-ventilated area, away from children and on a heat-resistant surface like marble or stainless steel. Use a soldering iron with a fine point and a metal ruler and, working on the heatproof base, melt off the excess fabric and seal all three layers together. This method is not suitable if you have used silk organza, as this will not melt, and thus will not fuse with the other layers.

11. As usual, test out soldering on your sample piece before attacking your artwork itself. This will help you get to know the speed, pressure and heat intensity of your soldering or stencil-cutting iron. To avoid breathing in the fumes created by the melting fabrics you should also wear a face mask.

12. When you are happy to proceed, gently draw a line with the soldering iron along the metal ruler on all four sides of your piece.

You can take it one step further and try to melt out some of the empty spaces between the stitch lines. Besides the health and safety warning, I should also warn you that this can become quite addictive!

Your finished piece is now ready for display. If you keep the piece to an A4 or letter size it can easily be scanned, reduced and made into a card, such as a Christmas card.

An Extra Experiment

Now, since you've got your polyester sheers and soldering iron out, try the following technique, which exploits the fact that polyester sheer fabrics melt when heated. I discovered it during a workshop with Alysn Midgelow at the Beetroot Tree gallery in Derby, UK. Be very careful, as (unsurprisingly) it involves heat again...

Materials and Equipment
- Photo to use as source material
- Small tea-light candle on a plate, with matches or a lighter
- Bowl of water for emergencies, in case any fabrics catch fire
- Small pair of pliers
- Several colours of polyester sheer fabric, including a light-coloured one for your backing
- A selection of hand- and machine-threads

Working from a suitable design source, you are going to build up layers of melted and burnt sheers to create colour washes similar to those in watercolour painting. By burning and melting the fabric over a flame, the sheers start to melt and crinkle, and the colour will become more concentrated.

1. Light your candle and have your bowl of water handy.
2. Cut a 50mm (2in) strip of polyester sheer and, holding it with the pliers, run it along the flame until it starts to melt. With some practice you will learn how long and how high to hold it above the flame before it melts. Playing around with this technique, you can create soft flowing edges, burn holes likes stones, and, if you cut squares of different sizes, you can burn them gently all around the edge until they become small cups, which you can place into each other to make pretty flowers. On their own they can make very authentic rocks or stones in a picture.
3. When you've got a good selection of different colours, shades and sizes, you can build up your picture in overlapping layers on a background of tulle or sheer fabric in a toning colour. Pin the layers into place and free-machine stitch to secure it all together in long wavy lines. If you wish, you can trap it all together with a top layer of tulle.
4. As there are no multiple layers of fabric and Bondaweb in a piece like this, the work can be stitched by machine and hand – a combination of both works extremely well.
A variety of embellishments can also be added, such as the following:
- Thicker threads of wool, cotton and strings of fleece couched on by hand or machine
- Chunky hand-dyed thread in big hand stitches
- Unravelled rope or raffia
- Beads
- Shells
- Buttons

Above: Photograph taken at the beach at Les Rochers. Use a photo that inspires you as your design source.

Right: **Les Rochers**. *This piece was inspired by the photograph above and was created during a workshop with Alysn Midgelow. We singed strips of polyester organza and placed these on water-soluble fabric. The work was then heavily embroidered and embellished by machine and hand before finally dissolving the backing. 18 x 30cm (7 x 12in).*

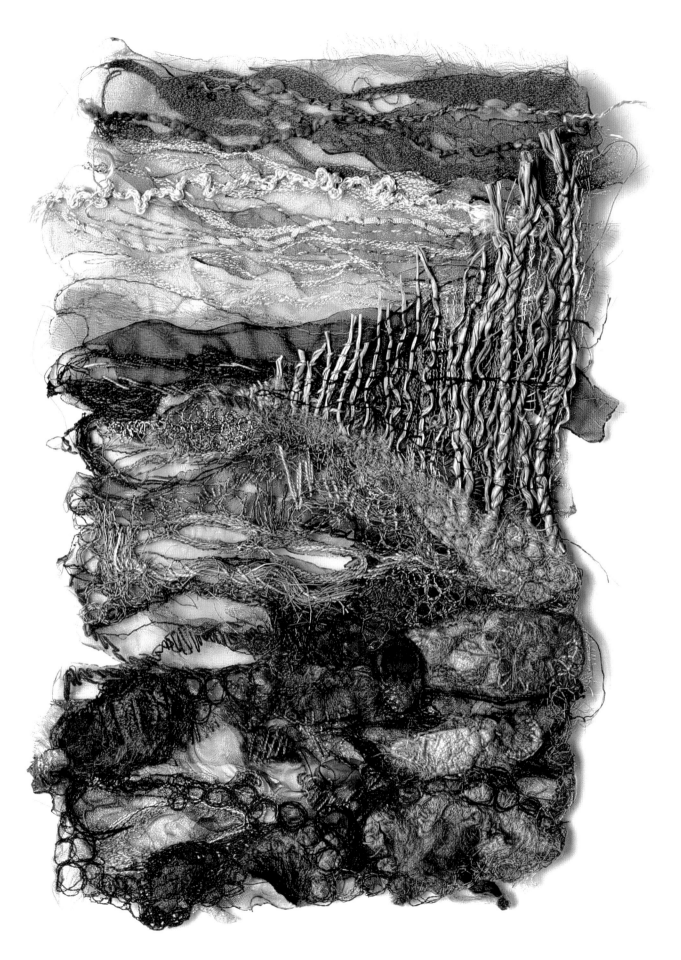

Your Landscape

We have almost come to the end of a colourful journey, and you should now be well and truly inspired to create an original landscape in textiles. Ideas of design, colour, pattern and stitch should be clear now, and your collection of fabrics is ready and waiting to be used.

For our final design you will need to decide on the size of your finished work – I like to work on an A3-size (297 x 420mm/11¾ x 16in) piece of paper – simply because it is easily available (at least, everywhere but North America, where legal-size paper can be used as a slightly smaller substitute). A3 is also a handy size to carry around to work on and, most importantly, not too large, so you can finish it in the foreseeable future!

As with all the other projects, your starting point will be a photograph of the landscape you love. You will have thoroughly researched the colours, the textures and the whole feel of this landscape, so transforming all this knowledge into a finished piece of contemporary textile art is something you are now equipped to do.

Right: This is a small version of **Omaha** *(page 21), made to try out texture, colour and stitches before embarking on the big piece. The following pages give instructions for creating a similar piece.*

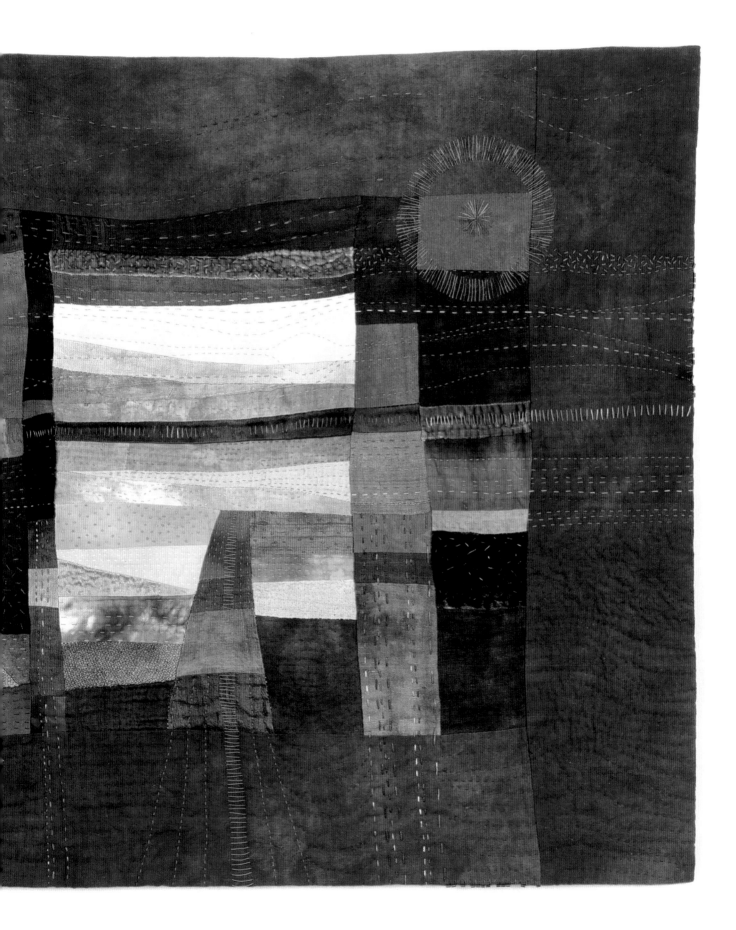

Gridlines

One of the basic elements of a good design is a simple grid. Ton Schulten starts his paintings this way, but the ancient Egyptians too divided the walls they were going to decorate into a network of verticals and horizontals. This way of composing a picture will give it the all important sense of balance and harmony.

To follow in the Egyptians' footsteps, we can also divide the A3 piece of paper into three or more sections horizontally. The most important line is the horizon itself, and you must be sure this one is perfectly level. The horizon can be right in the middle, but remember that if you place the horizon below the middle it will give you a bigger sky and a sense of space, while placing it above the centre of the page will add a feeling of distance. Then add some vertical lines, but leave the central section clear as a definite focal point.

If you copy these lines on a piece of lining paper it will enable you to paint on it with the brighter-coloured acrylic paints, which also have the advantage that you can overpaint them if you are not totally happy.

Right: **Small Omaha** *before assembly – the left-hand piece is shown as a work in progress on page 117.*

Below: A diagram showing the sections and colours that make up this small version of Omaha.

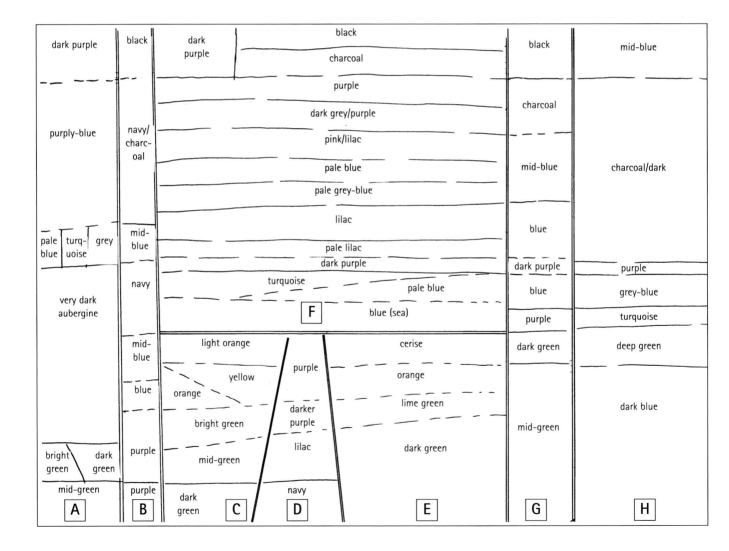

Filling in the Colours

Start filling in the squares with colours and build up your picture with geometrical shapes to create a landscape mosaic. Keep the following in mind:

• Choose your colour scheme carefully, and look at the complementary colours on your colour wheel.
• Keep the darker colours predominantly on the outer edges.
• Create a bright, 'postcard' centre.
• Bounce and balance colours around your picture: for instance, put a patch of green both in the top right and in the bottom left. You are free to use as many different colours and fabrics as you want, but if you use any particular fabric two or three times around your picture it will help to tie it all together.
• Turn the sky into a sky you love – make a feature of it. Along with the sun it is my favourite part of the design, and I like to make sure I start a piece with a good sky.
• If you are stuck, leave it for a bit and come back to it later. When translating your design into fabric you will probably find the right colour and texture. Remember too that you can add colour and texture with stitch.
• Add the trees, houses and so on later. Trees do not need to look realistically like trees, but with trunks and foliage you will still be able to recognize them as such. Keep the houses simple and light against a dark background.

When you are happy with your design you can start tracing it onto thin Vilene (Pellon), which can be left in, Stitch and Tear, or my personal favourite, greaseproof paper (butcher's paper).

Some sections might have to be subdivided, and it is a good idea to mark these clearly with letters or numbers and put a double outline around them. Trace each section separately, leaving a clear area of about 25mm (1in) all around so you can cut them into individual pieces. Copy the colours in words and mark the horizontal stitching lines as well. It also helps to copy the horizontal lines onto the back of the paper to use as a stitching guide later.

Now you can sort your fabrics. The choice is yours, but plain or small-patterned fabrics are the best. Hand-dyed cottons, with their textured colour, are just perfect for this kind of composition. But fabrics do not necessarily need to be cotton. I am sure if you go through your stash of fabric you will find all kinds of textures in good colours. Upholstery fabrics (not too thick), pieces of leather, old clothes, curtain remnants that have been lurking in the bottom of your drawer and all those other bits and pieces with which you could not part suddenly find their use!

Just to repeat the warning I mentioned at the painting stage: though it might be tempting to use a hundred different colours and textures – and such a piece of work might well turn out brilliantly – it is probably better to use any one fabric two or three times in your picture. Bouncing the colours around the picture will give you a more balanced result.

Remember to start with the darker fabrics on the outside pieces. Cut each piece generously – you will be surprised how big a piece you need, especially if it is placed at an angle – and pin roughly into place on your paper or Vilene. It is up to you whether you start at the top and work down or at the bottom and work up.

Traditionally, foundation piecing is done from the reverse side of the paper, but this will result in a mirror-image of your picture. I prefer to place the fabric on the top of my paper exactly as I see it on the design, pin it on from the back, check to see if it covers

dark to mid-purple

mid-purple/blue

mid-blue | turqu-oise | grey-blue

very dark blue/purple
charcoal

bright green | dark green

Above: Sample showing how to start section A of the foundation piecing. Place fabric on the top and pin, check and stitch from the back.

the required area and then stitch it from the back. Make sure you leave at least a 6mm (¹/₄in) seam allowance – maybe even up to 25mm (1in) – on the top and bottom pieces. This will give you some spare fabric to adjust the strip when assembling. Repeat this process for all the parts in your design.

Next, cut the sides of each strip neatly on a cutting mat with a ruler and rotary cutter down to the seam allowance (at least 6mm/¹/₄in). *Do not remove the paper yet!*

Assemble the sub-sections, then stitch all the strips together. To avoid bulk, open up the seams and press. Then straighten the top and the bottom. I prefer to leave the papers in until I have added the borders – they keep the shape better. Choose a border fabric in a dark colour that complements the picture. By placing the work on several fabrics you will find one that works better than the others. Cut strips of border fabric 100–150mm (4–6in) wide.

To achieve a finished piece that hangs straight you need to measure the width in the middle. Cut two strips of this length and sew these onto the top and the bottom. Next measure the height of the piece in the middle, cut two strips and stitch one to each side of the quilt.

Now you can take the papers out carefully, taking care not to rip the stitching. If you have used Vilene (Pellon), it can be left in place.

Adding Interest

A landscape picture needs a focal point, a centre of interest. It might already be an integral part of the design in the shape of a lake or a mountain, but sometimes it might be necessary to add perhaps one or two houses, a few trees, a sailing boat or some seagulls. They can be pieced as part of the original design, but it is much quicker and just as effective to bond them with Bondaweb (Wonder Under). As before, choose the appropriate fabrics and iron a piece of Bondaweb onto this. Cut out your house or tree. Peel the paper off and bond into place. Remember to leave a tiny gap between the Bondaweb and fabric to make it easier to peel off the backing paper.

To achieve a softer, layered effect for the trees, I rip small rectangles and squares of a variety of toning sheers and pin and hand-stitch them, overlapping them, but only at the very end when I have finished quilting and embroidering the piece. To do this any earlier would result in these small scraps fraying away.

Make up a 'sandwich' consisting of a backing fabric, wadding and your patchwork landscape. Tack together with large stitches in lines about 125mm (5in) apart or use a fusible 80 per cent polyester/20 per cent cotton wadding, as it does not need tacking or pinning. Just iron the back, then turn it over and iron the front. It is advisable to use a piece of baking parchment between the iron and the cloth to protect any man-made fibres that might melt if the iron is too hot.

Quilting the Design

If you keep all your materials in a little basket or case it means that you can pick it up and do some work anytime you have a few minutes to spare. I take mine when travelling, though to avoid having your scissors confiscated at the airport you might want to take a stitch ripper instead, or cut your threads beforehand. It's amazing how much you can achieve while waiting for a flight departure, and you can even be grateful if your flight is delayed, since you have all this extra stitching time!

Deciding where to begin the stitching process can be a daunting prospect. First, collect some threads in the colours of your picture, and in several shades and textures, together with needles and scissors.

I like to use a combination of hand and machine quilting. Treating each square as a separate 'field', you can start by hand-stitching, and perhaps add some machining later on. Or if you prefer, the picture can be completely embroidered with the sewing machine. Playing around with the preset stitches of your machine can be great fun, and very revealing, since you may discover stitches you didn't know the machine could produce. I always find that a green field in my landscape design is the obvious place to start filling in with some hand- or machine-stitches resembling grass.

New or old embroidery books are fantastic sources for finding unusual stitches, but more often than not the simple straight running stitch can give endless possibilities, and produce beautiful shadows and rippled textures. (Take a look at the stitches on page 80.)

Often while stitching one part, you will get an idea about how to continue with another square. Another good way of deciding what stitch to use is to take one or more black-and-white photocopies of your work and draw quilt lines onto it, or sketch onto tracing paper placed on top of your photocopy. Again, this is another opportunity to fill some pages of your sketchbook with doodles and quilt ideas.

Your choice of thread colour will depend on whether you would like it to blend in and produce texture. To achieve this, use a shade lighter or darker than the background, which gives the added advantage of hiding small mistakes, especially when free-machine quilting. This would not be so easy if you were using a contrasting thread.

The photograph you used as your starting point can also give inspiration for your stitching and choice of colour. Somewhere in the landscape you might find a grid pattern in a fence, a garden trellis or a hedge. Explore these in your sketchbook, make marks, work and rework them in different proportions, and mirror-image the pattern – the variations are endless. In the paintings of Ton Schulten there is often a pathway leading to a house or a wood that can be made into a focal point with simple decreasing lines. Remember also that taking the coloured stitching through into the border pulls the frame into the picture.

For extra embellishment, adding a dash of sparkle is great fun – a few stitches or French knots with a silver thread can work very effectively in suggesting a stretch of water. A sprinkling of beads gives glittery texture and interest. Small pieces of metal can also be stitched by machine. Printer's foil pressed on thin slivers of Bondaweb while it is still hot is a very quick way of adding lustre.

Project: Making a Tote Bag

Everybody loves making bags, whether they are for you or to give as a present, and this book would not be complete without one. I have adapted one of my favourite designs into a bright and seasonal tote bag. It is easy and fun to make and the bits of suede and leather will give your bag some real class. You can use the same colours or adapt them to your personal taste.

Below: My **Vendée Globe** *design works well as a sturdy, summery tote bag.*

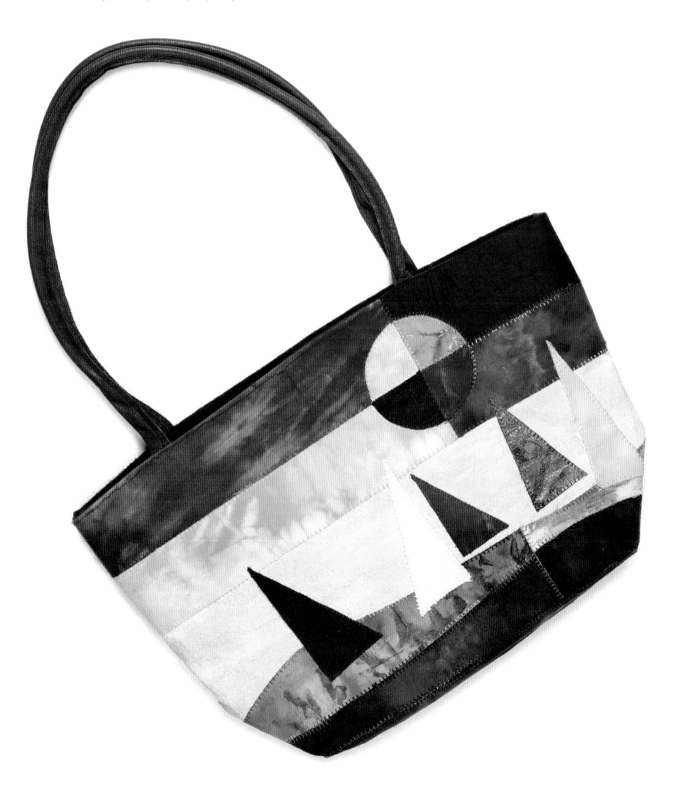

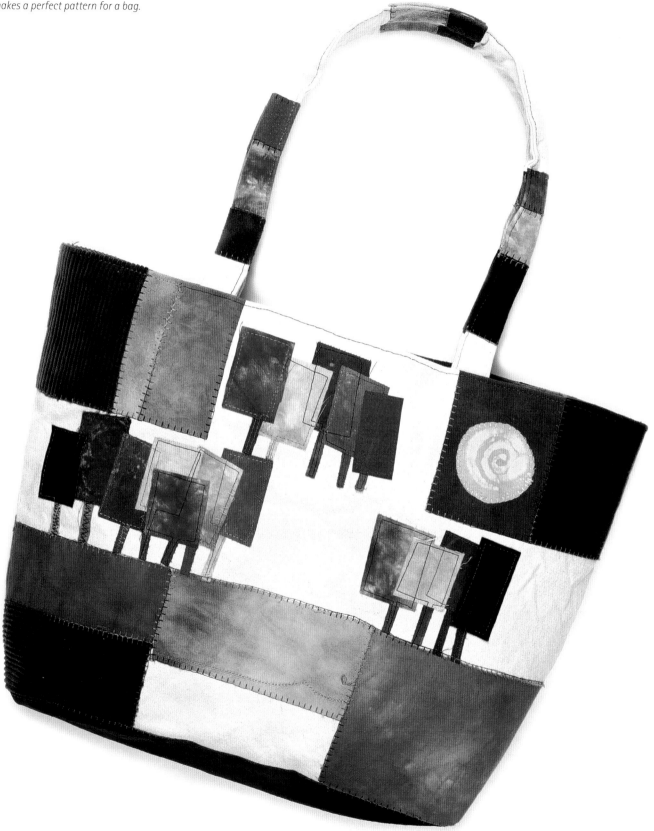

Below: My **Autumn Trees** *design also makes a perfect pattern for a bag.*

fig 1

42cm (16½in)

30cm
(11¾in)

30cm (11¾in)

folded fabric

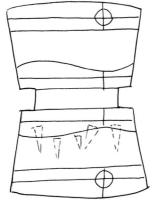

13cm
(5in)

60cm (24in)

fig 2

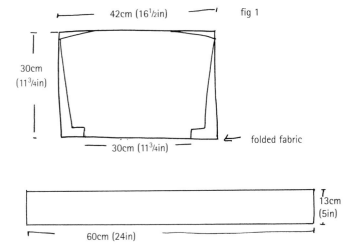

fig 3

Materials and Equipment
- 750mm (30in) of strong canvas
- 1m (39in) of Bondaweb (Wonder Under)
- 800mm (31½in) of cotton fabric for lining
- 1.25m (49in) cord or plastic tubing (10mm/³/₈in diameter) for handles
- Magnetic fastener or press stud
- Bits of leather
- Coloured fabrics for appliqué
- Matching threads

1. Referring to the diagrams, copy your chosen bag design onto a sheet of A3 paper. If you like a deeper bag you can add a few centimetres at the top; remember to extend the coloured pattern pieces too.

2. Place this pattern with the bottom end on the fabric fold, then cut:

- One bag out of the canvas with a generous 6mm (¼in) seam allowance to enable a fitting construction of the base. The cut-out corners need to be 25 x 25mm (1 x 1in), giving you a 50mm (2in) wide base (see fig 1).
- A canvas strip 500 x 125mm (20 x 5in) for the handles (see fig 2).
- One bag out of the cotton lining fabric, slightly smaller, with 25mm (1in) cut-out corner squares as on the bag.
- Two pieces of cotton lining fabric of 500 x 200mm (20 x 8in), for pockets.

3. Trace a mirror image of the pattern onto the paper side of Bondaweb; repeat on a second piece.

4. Cut the pieces and iron them onto the appropriate colour, then cut out of fabric, peel off the paper and iron in place onto both sides of the bag. It's nice to use a few bits of leather or suede here, and in the handle as well.

An alternative but more relaxed method of cutting the shapes is to select several pieces of coloured fabrics, iron an A5-sized (148 x 210mm/5¾ x 8¼in) piece of Bondaweb (Wonder Under) on the back of each, and cut the pieces freehand out of the fabrics. Place on the bag and fuse.

fig 4

place on fold

cutting line

5. Apply the background pieces first (see fig 3 on page 121). With thread to match – I like to use a suitable variegated thread – stitch with a buttonhole or small zigzag stitch around each section of the appliqué. Then add the trees or boats and stitch around these with a straight or zigzag stitch. It is possible to do the trees in one stitch line (see fig 4 on page 121), avoiding loose threads to finish off later.

6. With the right sides together, machine the side seams and press them open (see fig 5). Then pin the bottom edge seams together and stitch across (see fig 6).

7. Take the strip of canvas you cut for the handles and appliqué several strips of the different fabrics you've selected, using Bondaweb. Stitch as for the bag (see fig 7).

8. Cut the handle piece in half along the length and iron a 3mm (1/8in) seam towards the inside on both sides of each strap. Place a length of tubing in the middle section, pin, and stitch with a zipper foot (see fig 8).

9. Pin the handles on the right side of the bag, with the handles hanging down (fig 9).

fig 5

fig 6

- cut fig 7

fig 8

fig 9

fig 10
lining

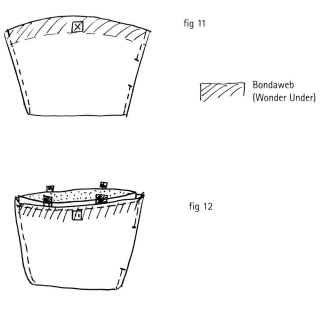

fig 11

⬛ Bondaweb
(Wonder Under)

fig 12

10. Stitch a hem on both sides of the pocket and sew in the middle of the lining, stitching through as shown in fig 10.

11. Stitch the side seams of the lining but leave a gap of approximately 100 mm (4 in) at the bottom of one side to turn the bag. Then pin the bottom edge seams together and stitch across as in figs 5 and 6.

12. To strengthen the place where you will attach the fastener, cut two pieces of canvas, each 50 x 75mm (2 x 3in) and iron them about 13mm (1/2in) from the top, in the middle of the wrong side of the lining, using Bondaweb (see fig 11).

Approximately 25mm (1in) from the top attach the magnetic fasteners – one on each side, exactly opposite each other. This will leave enough room to pass with the sewing machine foot when top-stitching later on.

13. Iron a 50mm (2in) strip of Bondaweb across the whole of the top as in fig 11, again on the wrong side of the lining bag and over the back of the fastenings. This will give the bag extra strength on the top. (When you finally turn the bag you can iron these layers together.) Peel off the Bondaweb paper.

14. Leave the lining bag inside out and place the canvas bag inside it (see fig 12).

15. Pin along the top with the right sides together and stitch along the top with the handles inside.

16. Turn the bag carefully through the gap in the side seam of the lining and close the gap, by machine or hand.

17. Pin and topstitch along the top of the bag – go slowly to avoid breaking the needle – then run the iron over the top to fuse the Bondaweb on both sides together.

Bibliography

Barnes, Christine. *Color: The Quilter's Guide.*
That Patchwork Place, 1999.

Beaney, Jan and Littlejohn, Jean.
A Complete Guide to Creative Embroidery.
B T Batsford, 1997.

Finlay, Victoria. *Colour: Travels Through the*
Paintbox. Sceptre, 2002.

Hamm, Jack. *Drawing Scenery: Landscapes*
and Seascapes. The Berkley Publishing
Group, 1972.

Harding, Valerie. *Textures in Embroidery.*
B T Batsford, 1977.

Howard, Constance. *The Constance Howard*
Book of Stitches. B T Batsford, 1979.

Issett, Ruth. *Colour on Paper and Fabric.*
B T Batsford, 2000.

Jinzenji, Yoshiko. *Quilt Artistry: Inspired*
Designs from the East. Kodansha
International, 2002.

Johnston, Ann. *Color by Accident: Low-Water*
Immersion Dyeing. Ann Johnston, 1997.

Meech, Sandra. *Contemporary Quilts:*
Design, Surface and Stitch. B T Batsford,
2003.

Monahan, Patricia. *Landscape Painting.*
Eagle Editions, 2004.

Mori, Joyce and Myerberg, Cynthia. *Dyeing*
to Quilt: Quick Direct-Dye Methods for
Quilt Makers. Contemporary Books, 1997.

Warren, Verina. *Landscape in Embroidery.*
B T Batsford, 1986.

MAGAZINES AND JOURNALS

Selvedge
PO Box 40038
London N6 5UW
www.selvedge.org

Quilting Arts Magazine
PO Box 685
Stow, MA 01775,
USA
www.quiltingartsllc.com

SOCIETIES AND GROUPS

The Quilters' Guild
www.quiltersguild.org.uk

The Embroiderers' Guild
www.embroiderersguild.com

The Textile Society
www.textilesociety.org.uk

Suppliers

Art Van Go
The Studios, 1 Stevenage Road
Knebworth, Hertfordshire SG3 6AN
Tel: 01438 814946
www.artvango.co.uk
General art supplies

Kemtex Colours
Chorley Business and Technology Centre
Euxton Lane, Chorley, Lancashire PR7 6TE
Tel: 01257 230 220
www.kemtex.co.uk
Dyes

Omega Dyes
3–5 Regent Street, Stonehouse
Gloucestershire GL10 2AA
Tel: 01453 823 691
www.omegadyes.co.uk
Dyes

Whaleys (Bradford) Ltd
Harris Court, Great Horton
Bradford, West Yorkshire BD7 4EQ
Tel: 01274 521 309
www.whaleys-bradford.ltd.uk
Fabrics

The Textile Directory
Word4Word Design and Publishing Ltd
Suite 8, King Charles Court
Evesham, Worcestershire WR11 4RF
Tel: 0870 220 2423
www.thetextiledirectory.com
Directory of fabric suppliers

Margaret Beal Embroidery
Tel: 01264 365102
burning.issues@margaretbeal.co.uk
Fine-tipped soldering irons

Creative Grids
Unit 5, Swannington Road
Cottage Lane Industrial Estate
Broughton Astley, Leicester LE9 6TU
Tel: 08454 507 722
www.creativegrids.com
Rulers, threads and other quilt supplies

equilter.com
5455 Spine Road, Suite E,
Boulder, CO 80301, USA
www.equilter.com
Threads, tulle and other quilt supplies

Index